Moonstruck:
Images from Atwood

Moonstruck: Images from Atwood

Copyright 2015 by Echo Hill Arts Press, LLC.
All rights reserved, including the right to reproduce any or all of the contents of this book.
ISBN: 13: 978-1519561626
ISBN: 10:1519561628

Inspired by my moonstruck friend, Marjorie.

ECHO HILL ARTS

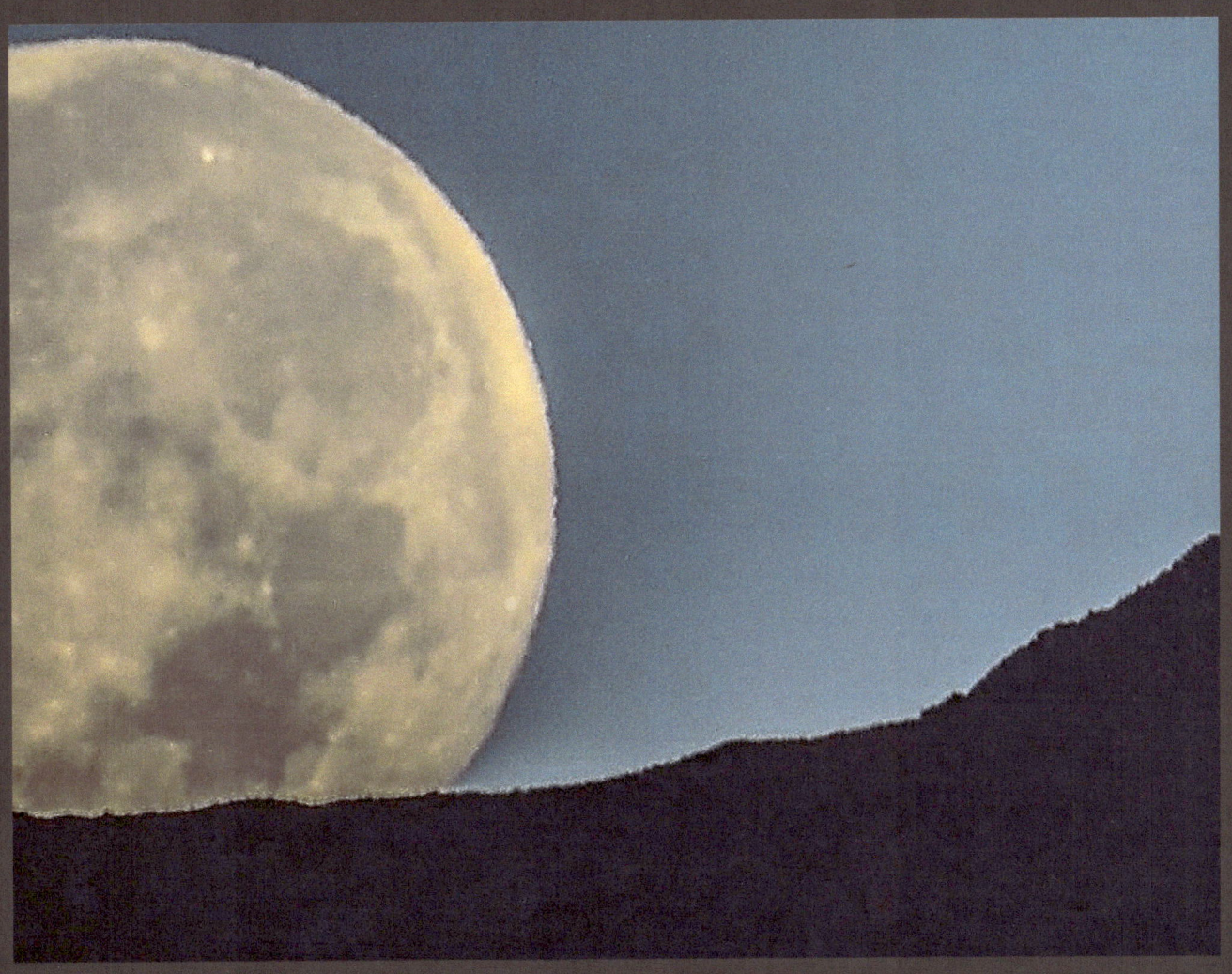

Is there anyone who is *not* fascinated by the moon?

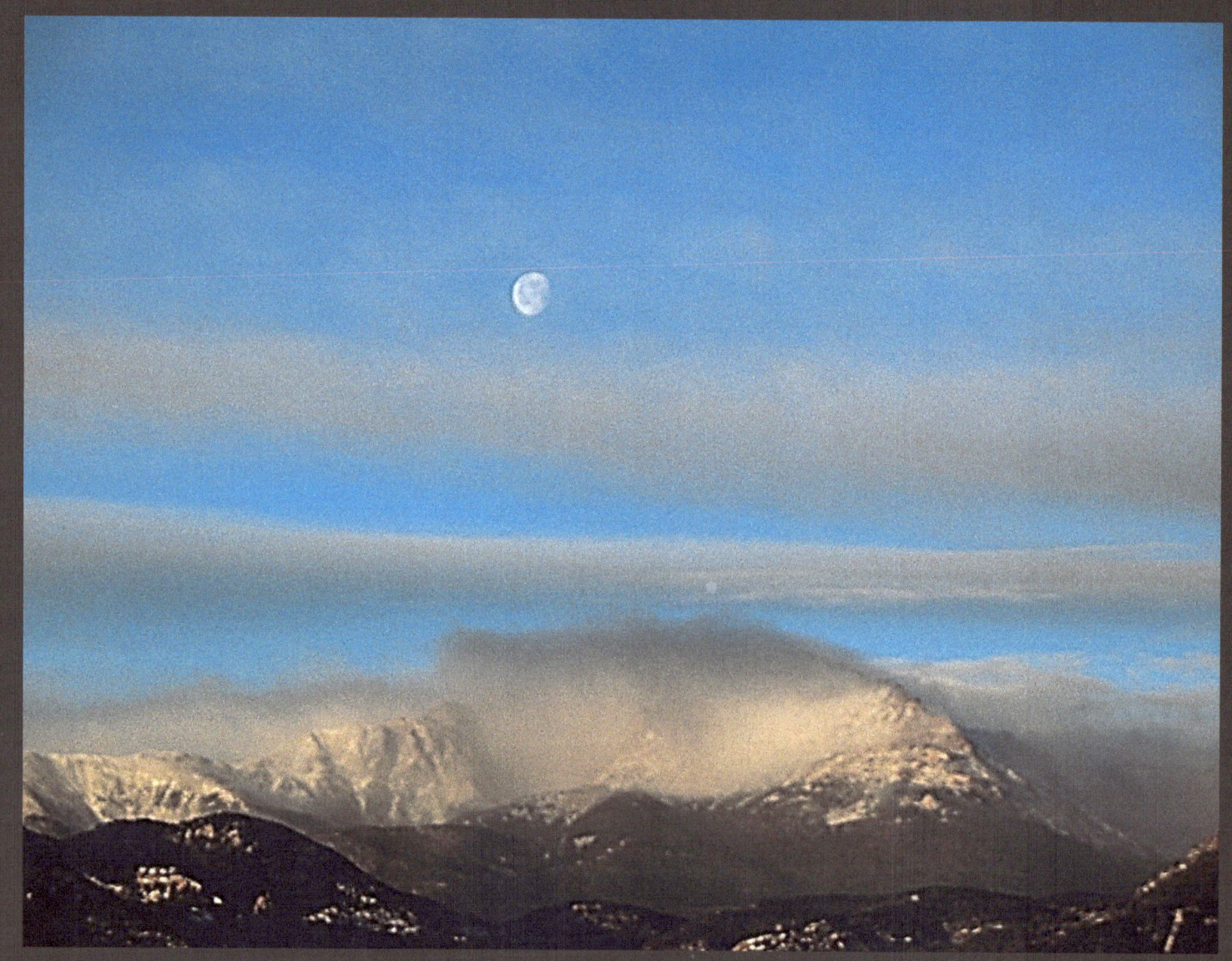

I know I am.

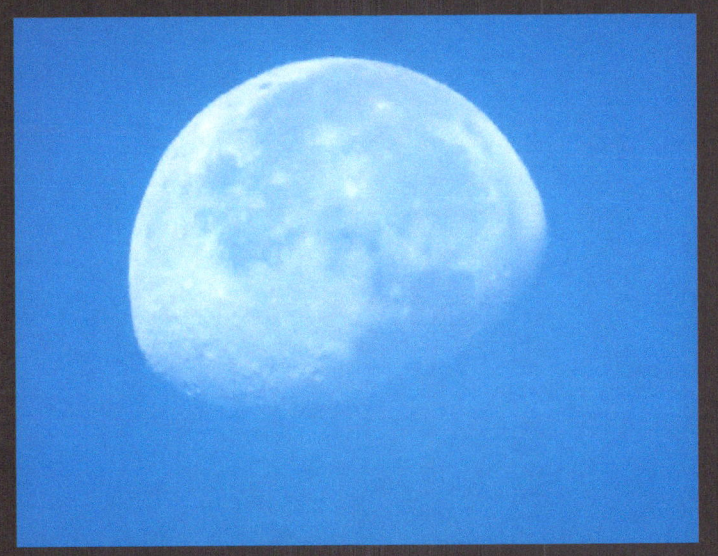

The sight of
a waning gibbous
arrests me.

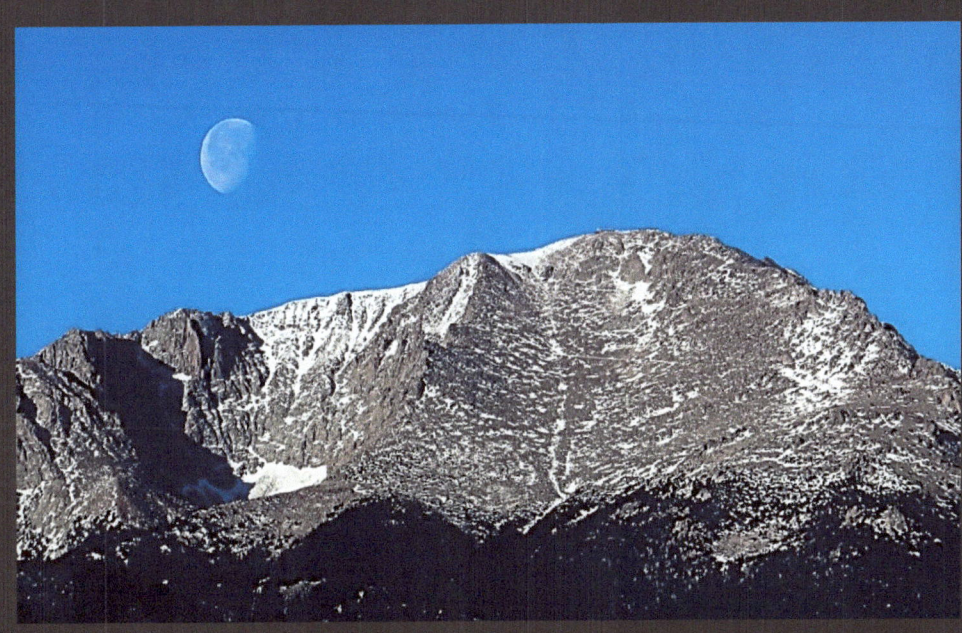

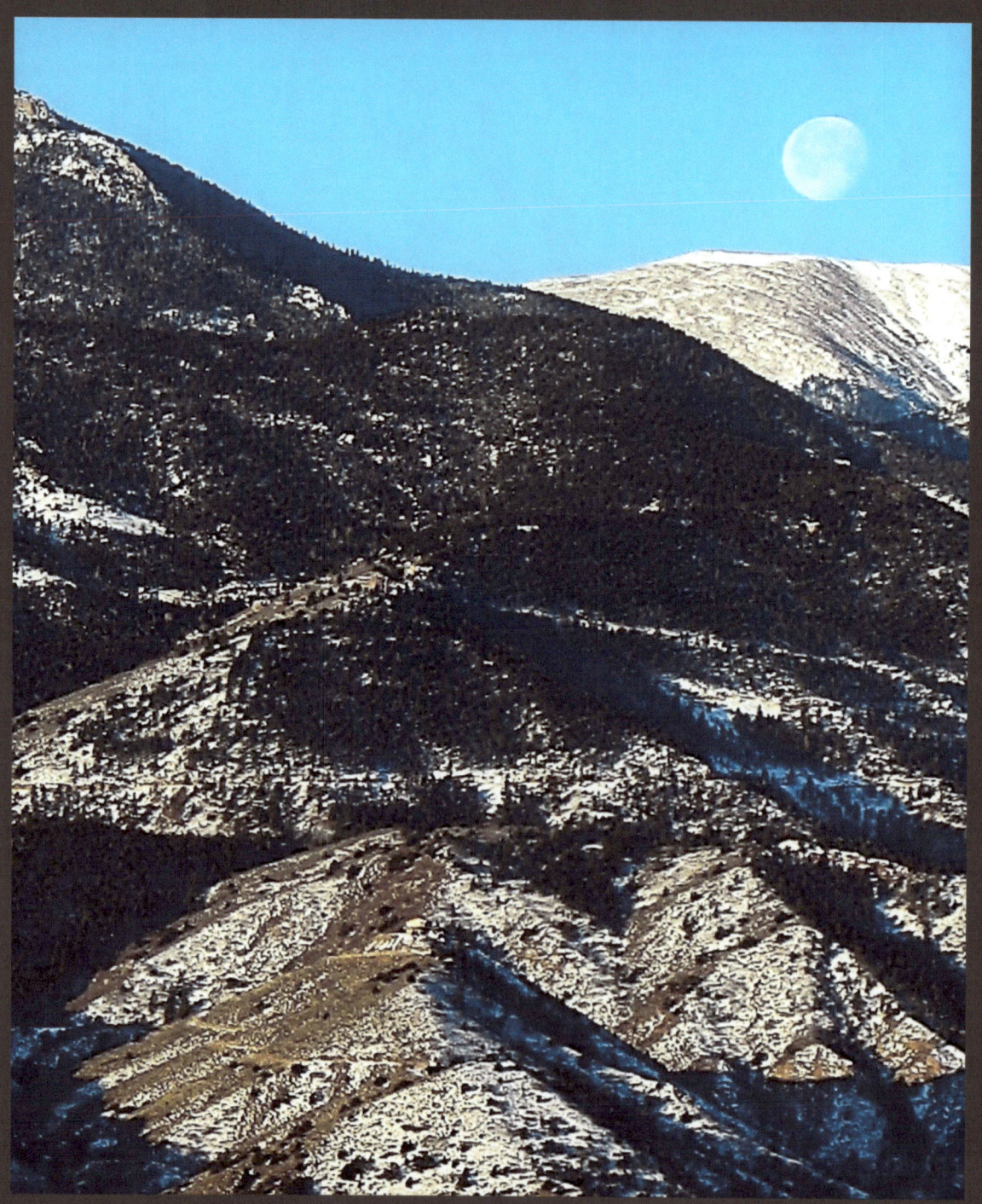

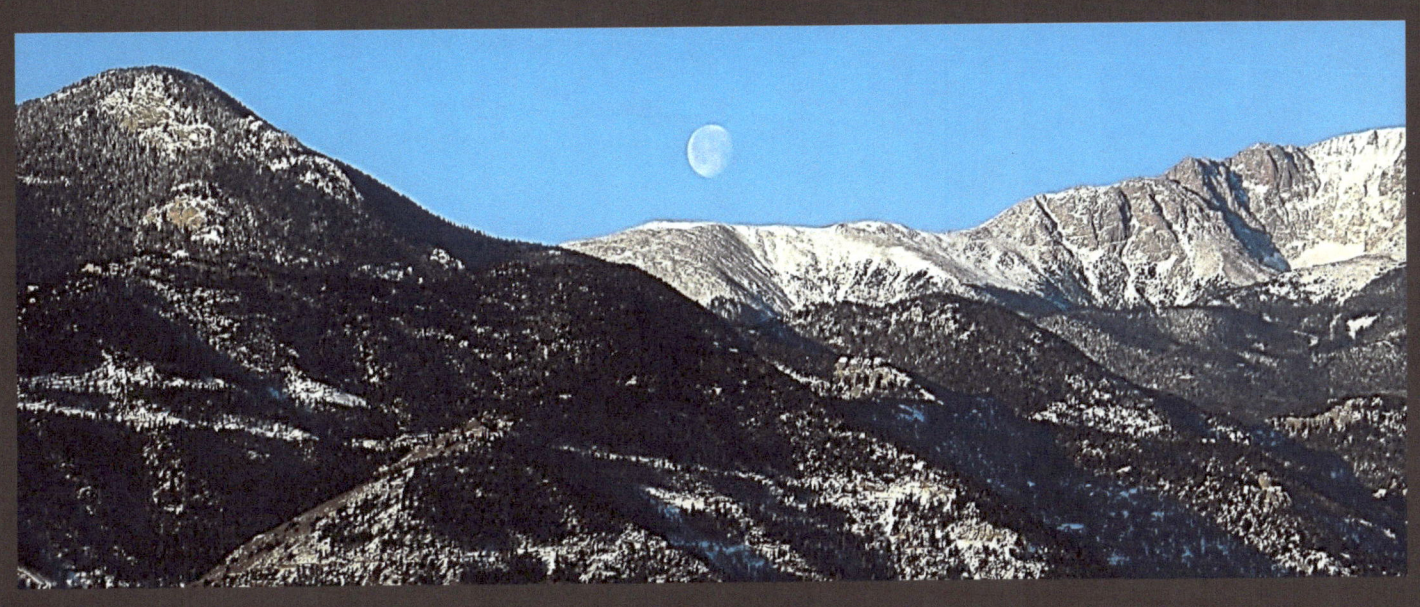

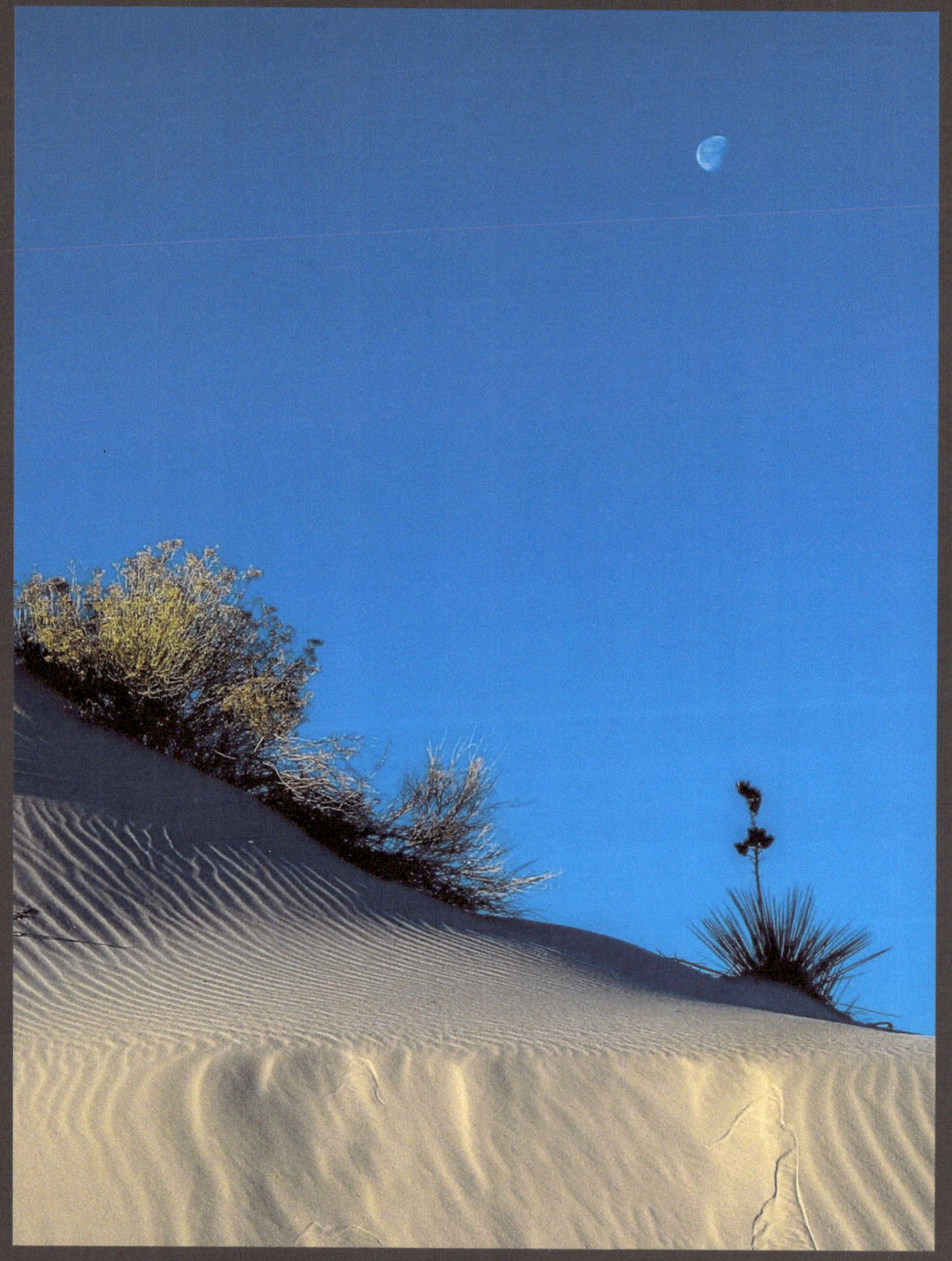

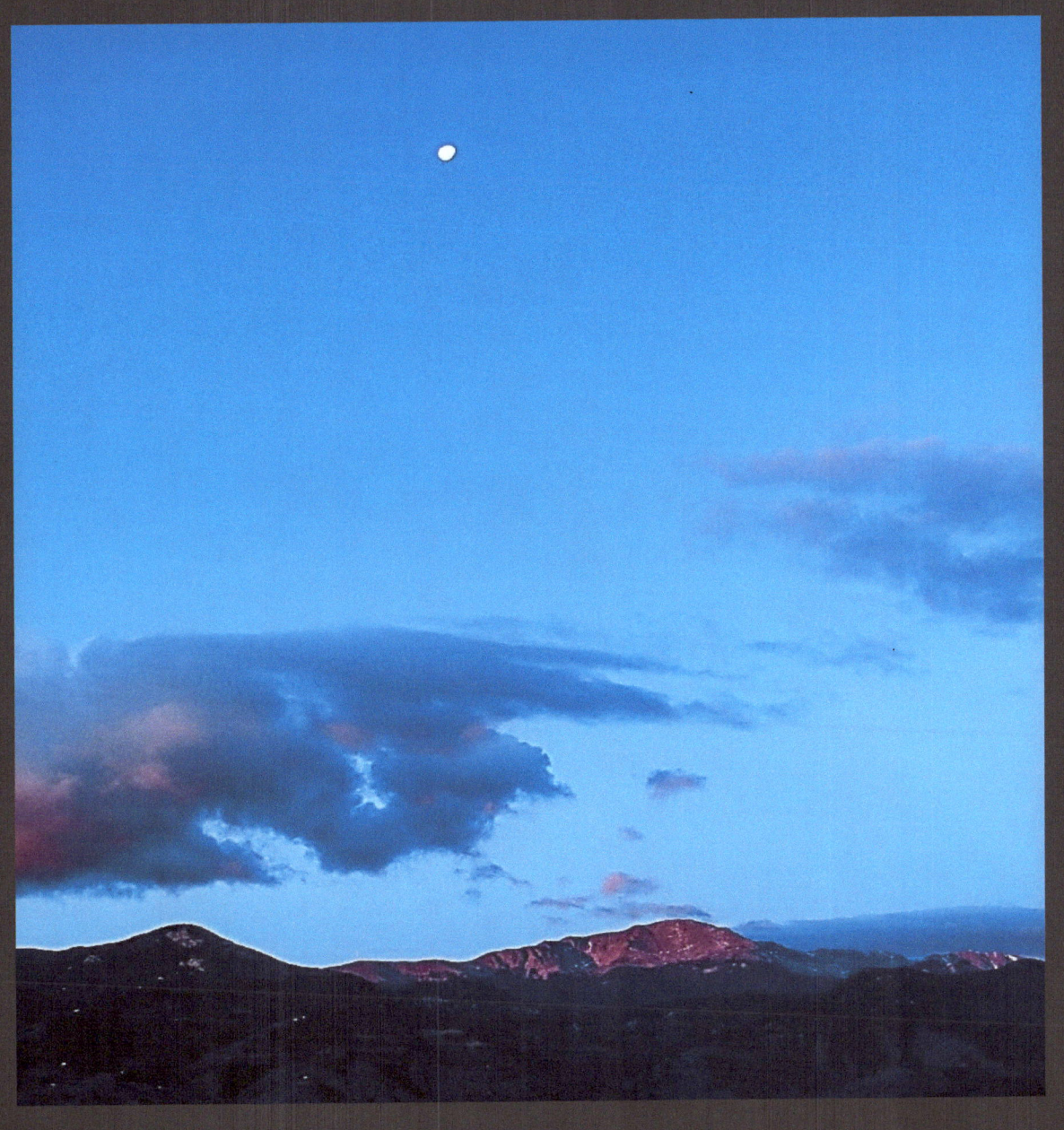

Over a week I watch, knowing that I am powerless
as my Luna withers and wanes.

...Then she is gone.

But soon her crescent shape peeks out of the darkened night, and she waxes anew.

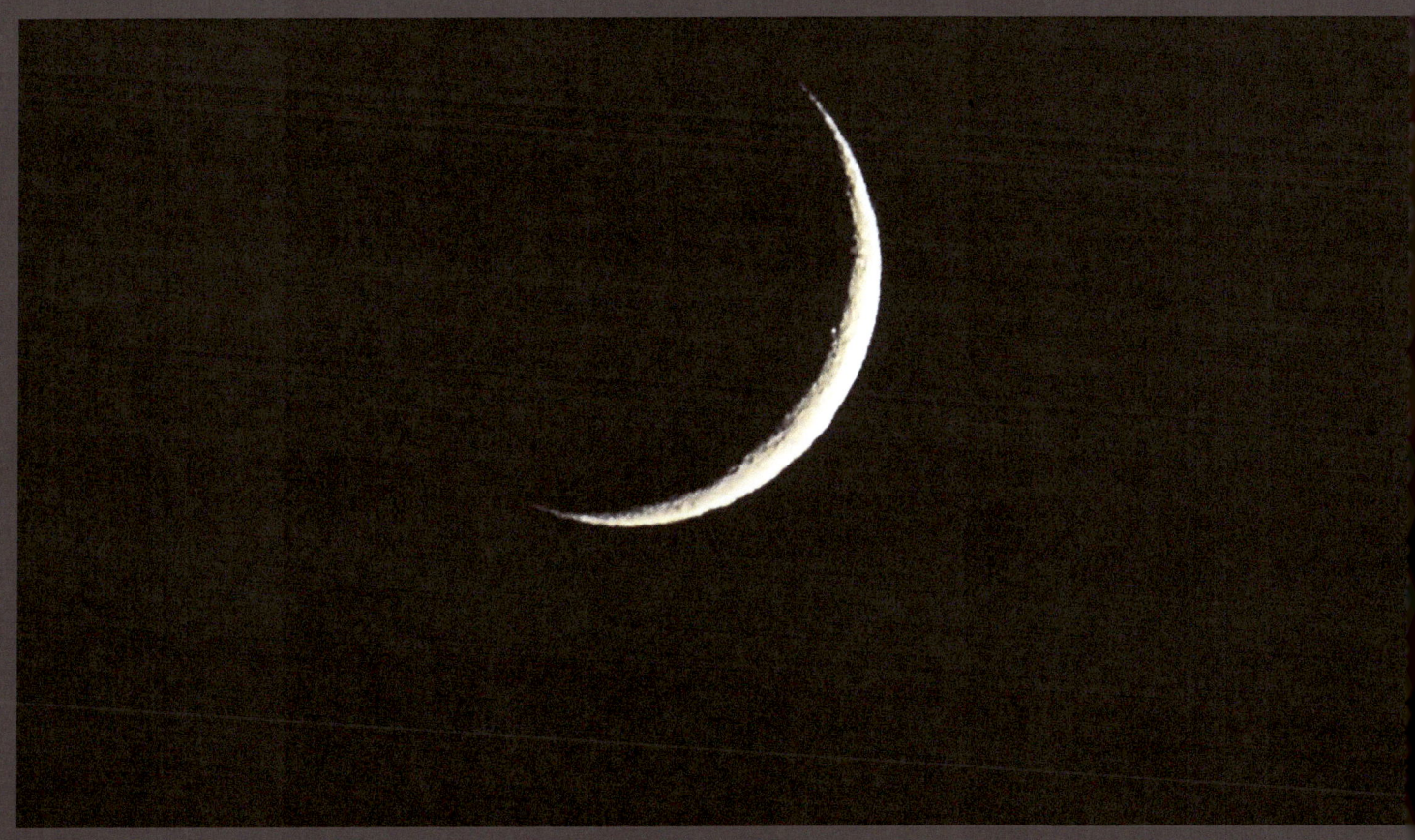

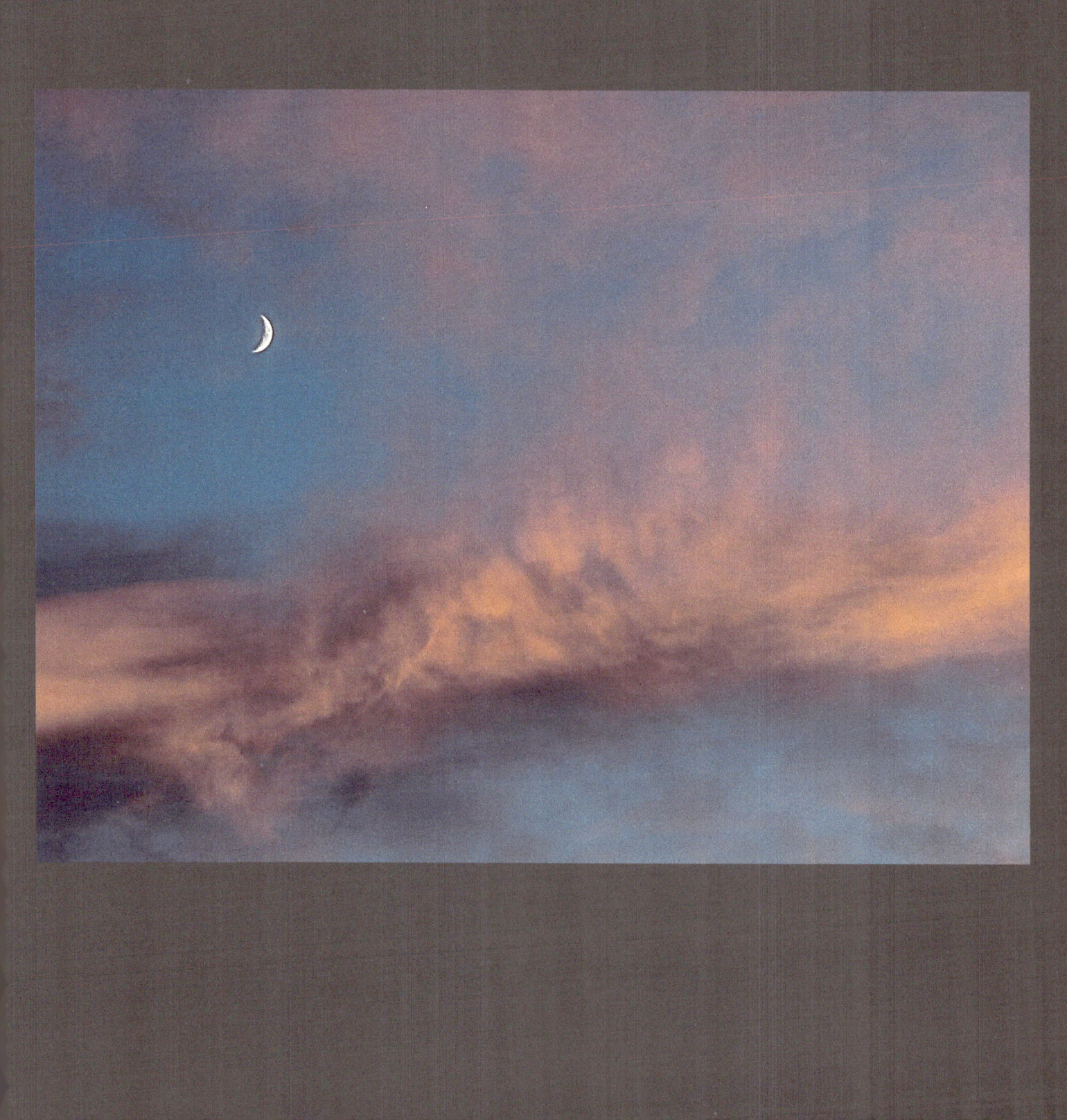

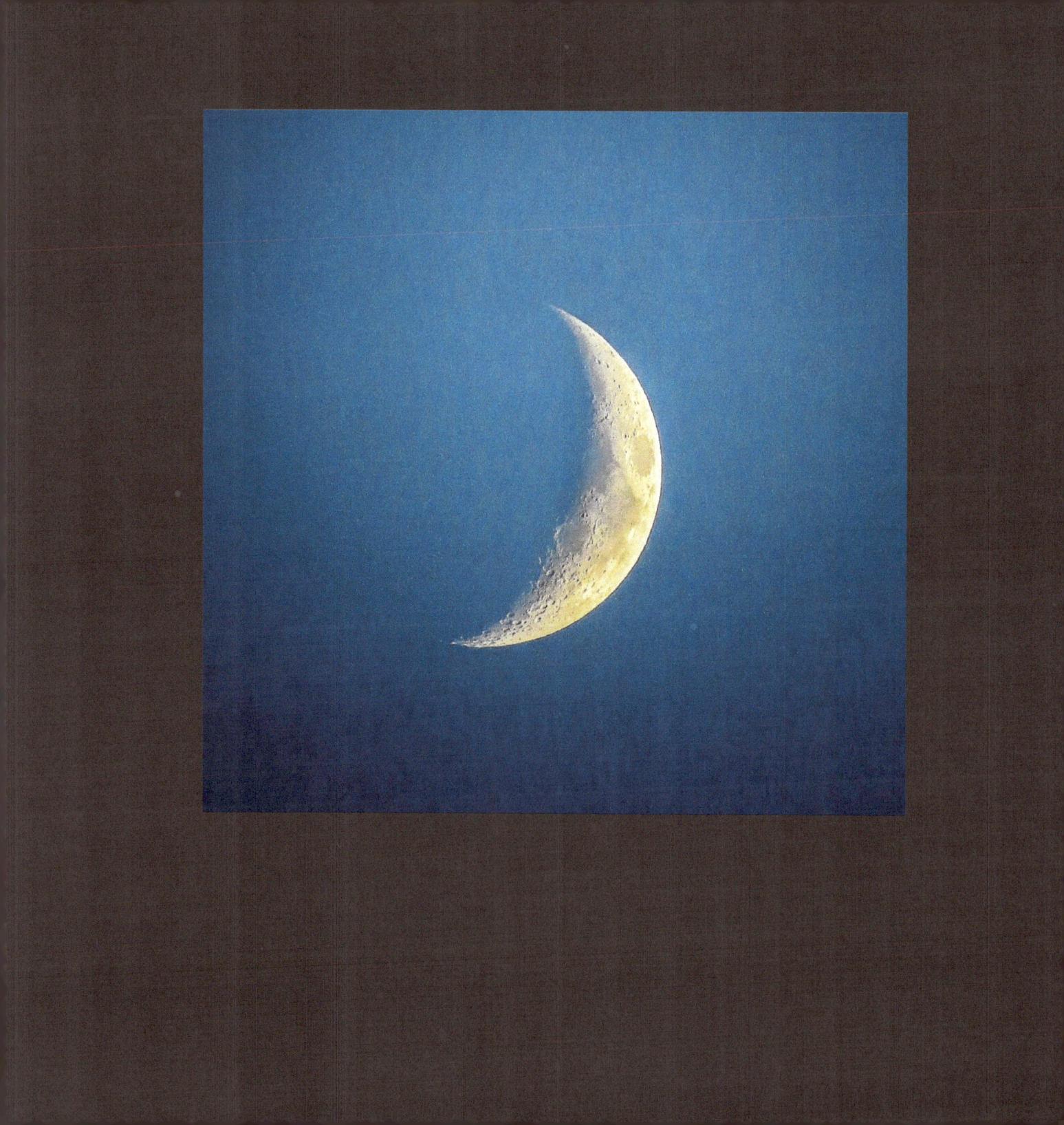

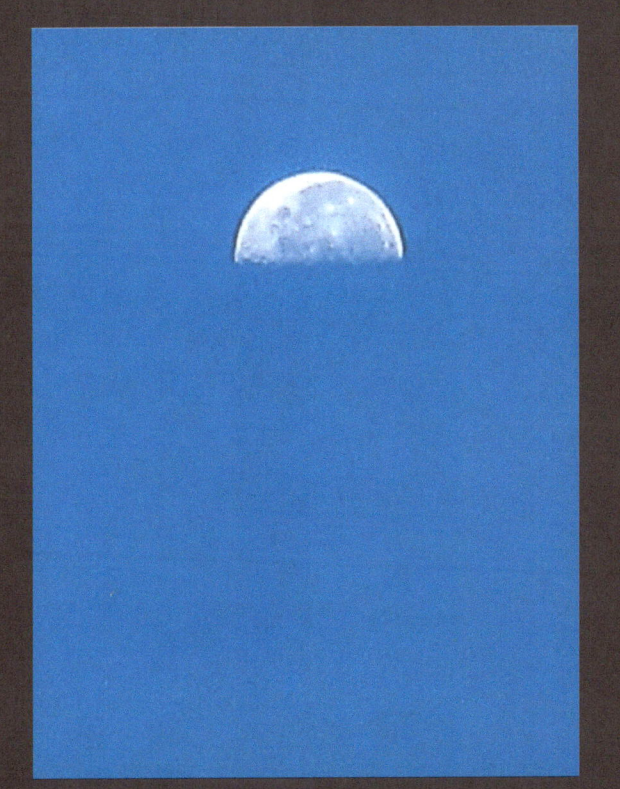

When she is nearly gibbous,
then I will know
that her full face is coming.

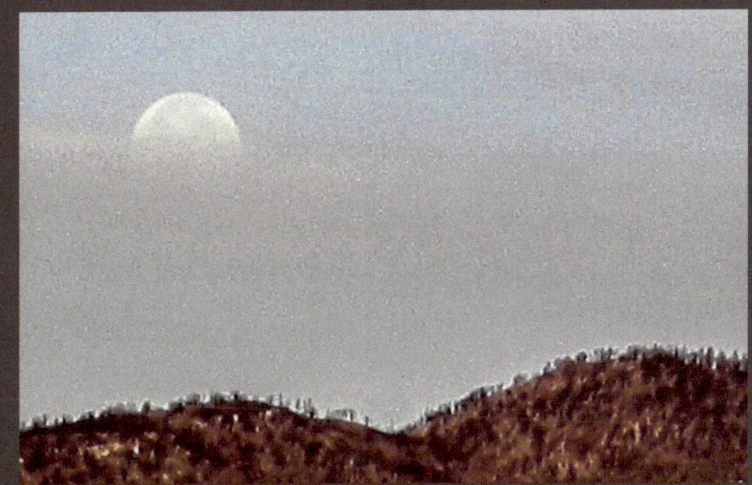

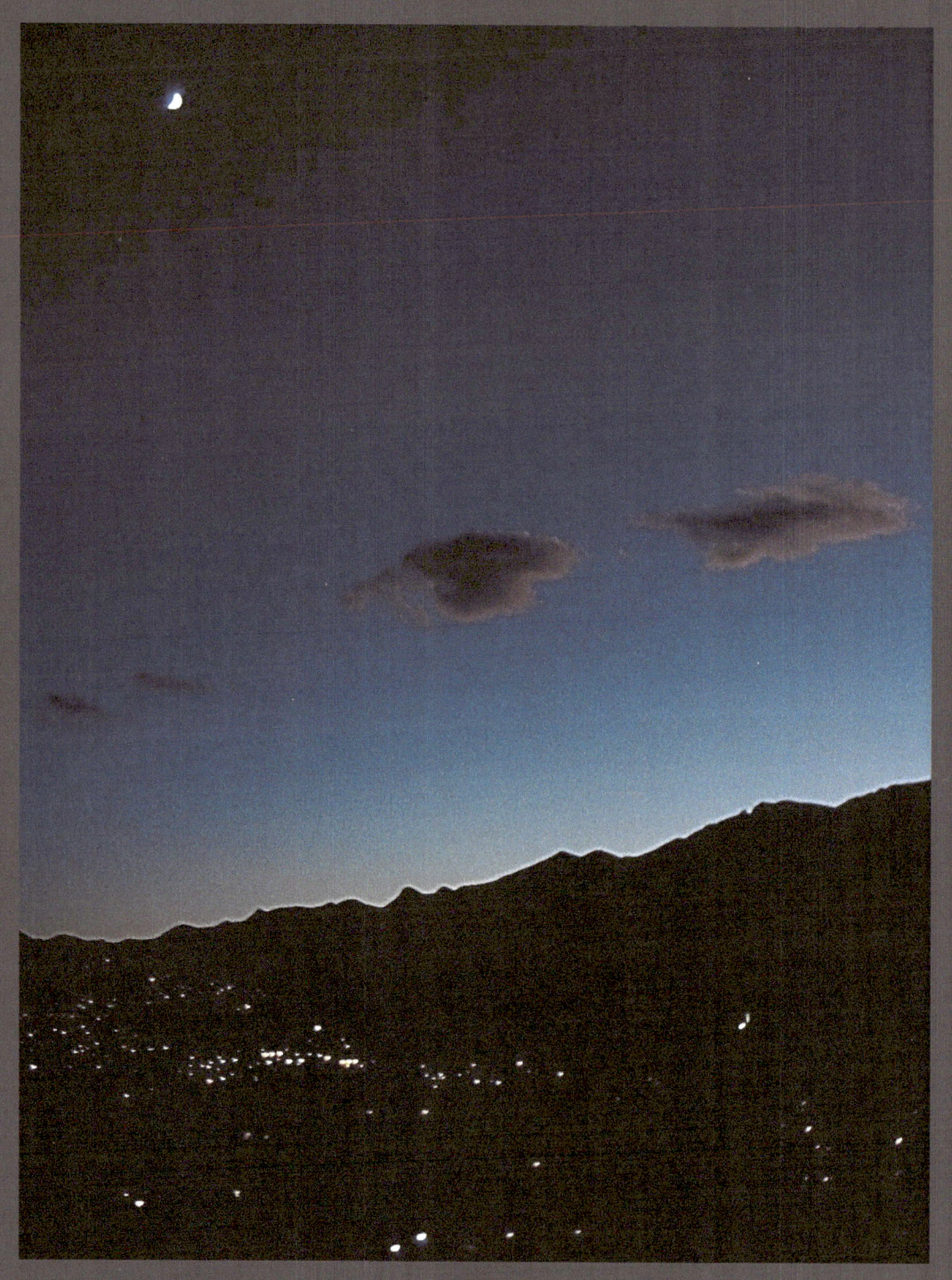

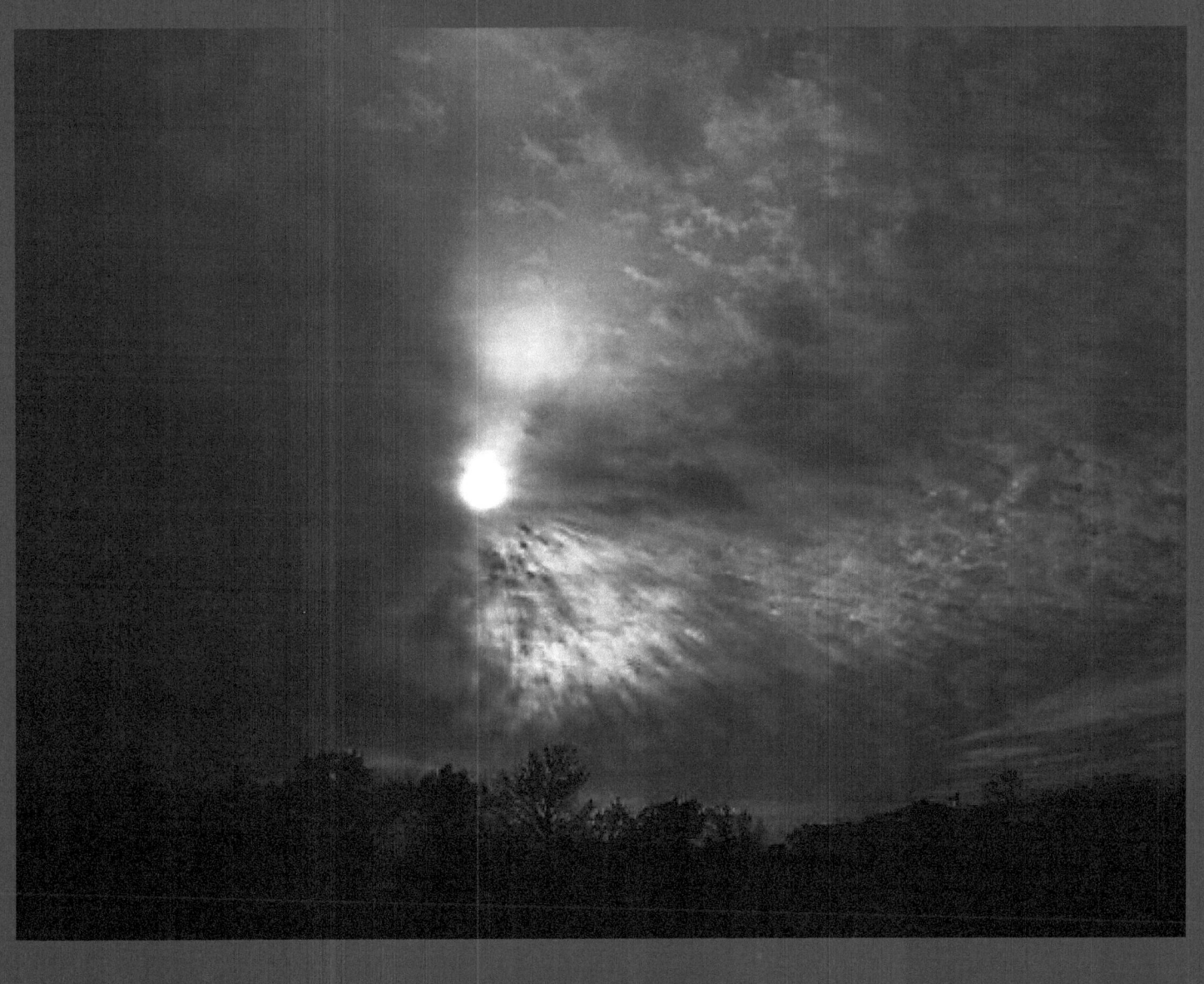

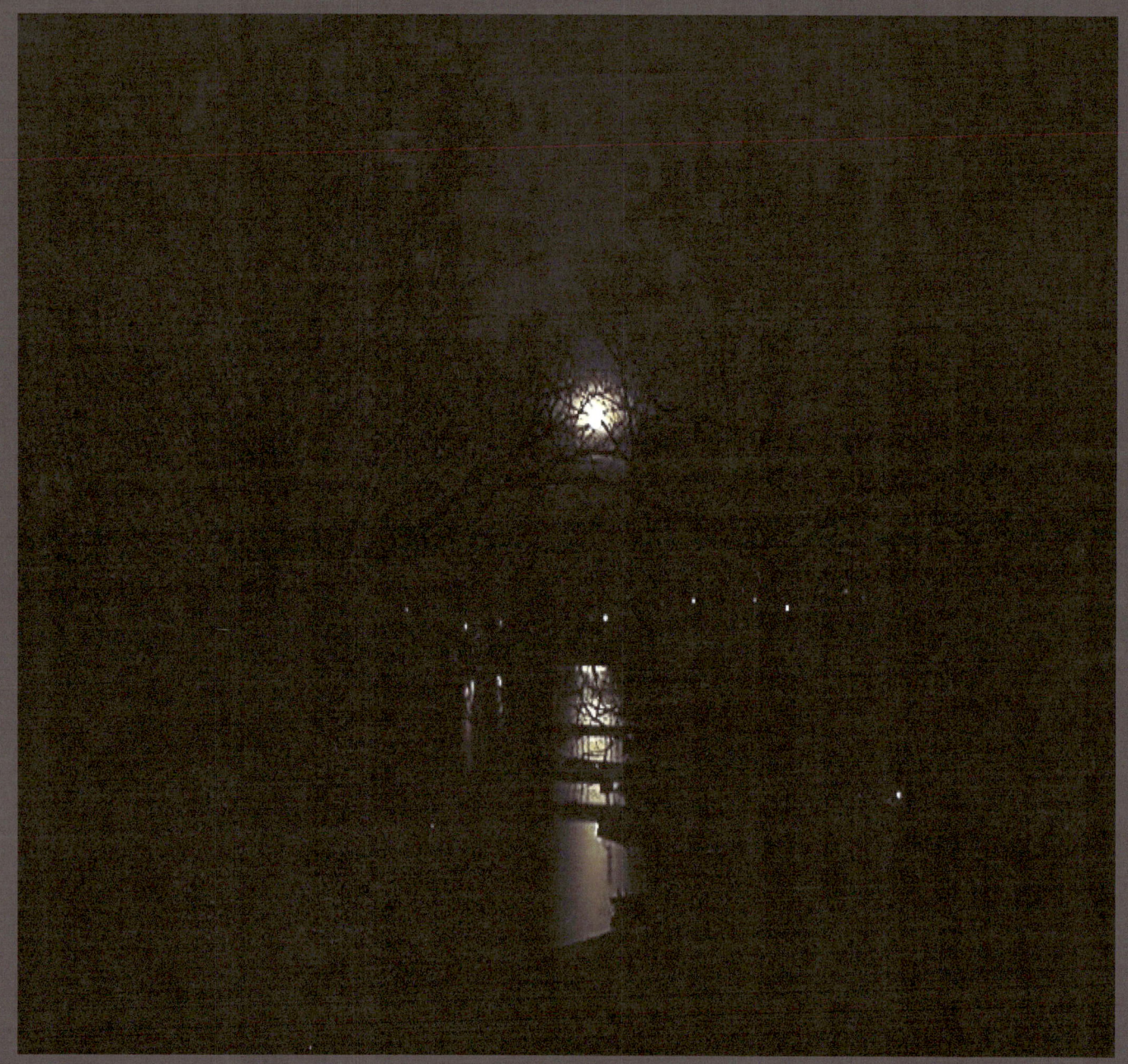

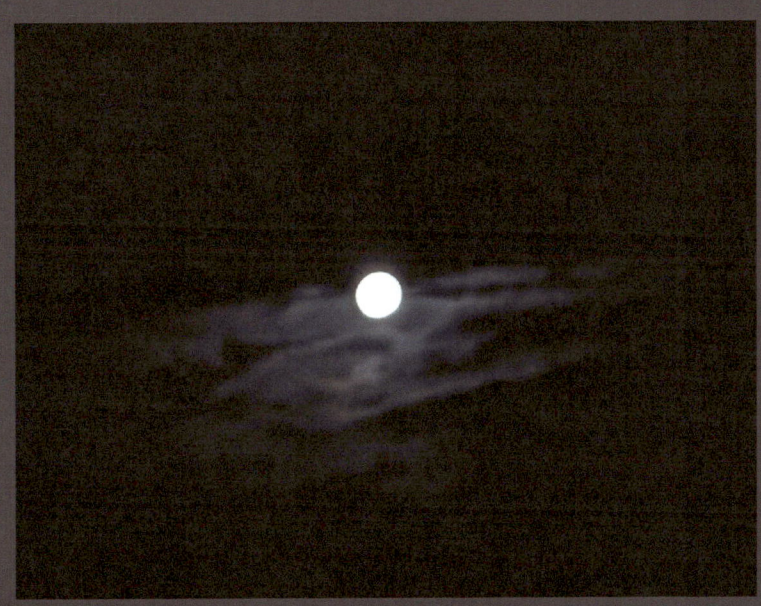

Her round rising
will lend enchantment to the night.

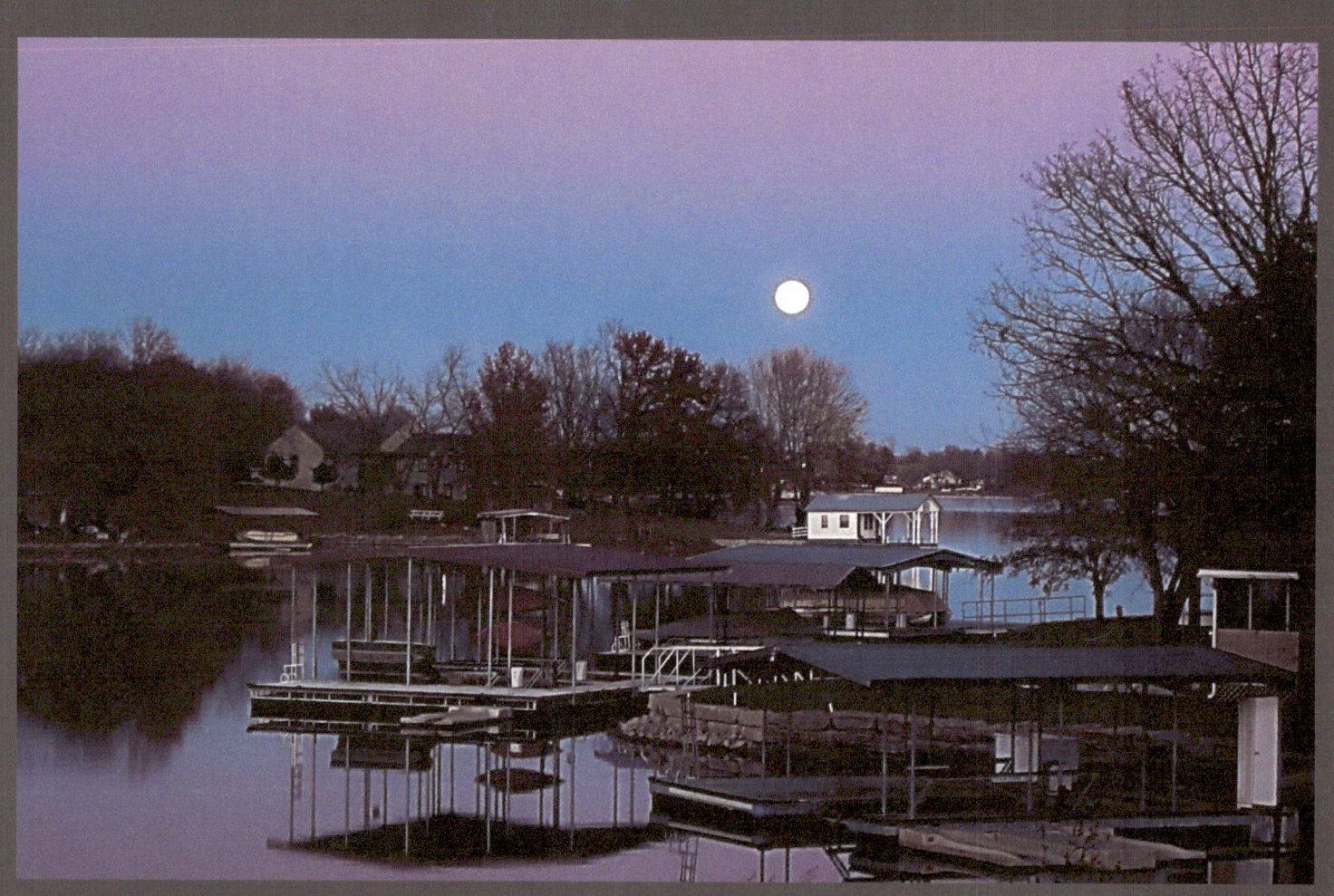

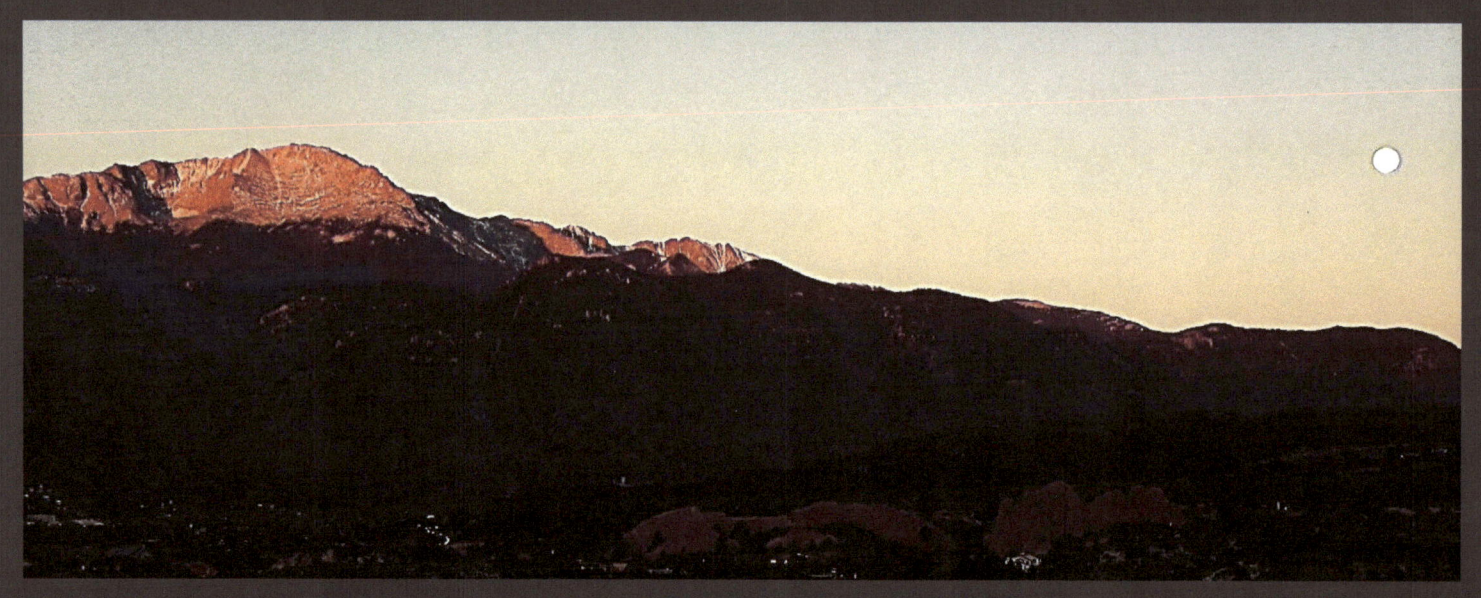

Her fleeting departure at dawn
will captivate all who trace her progress.

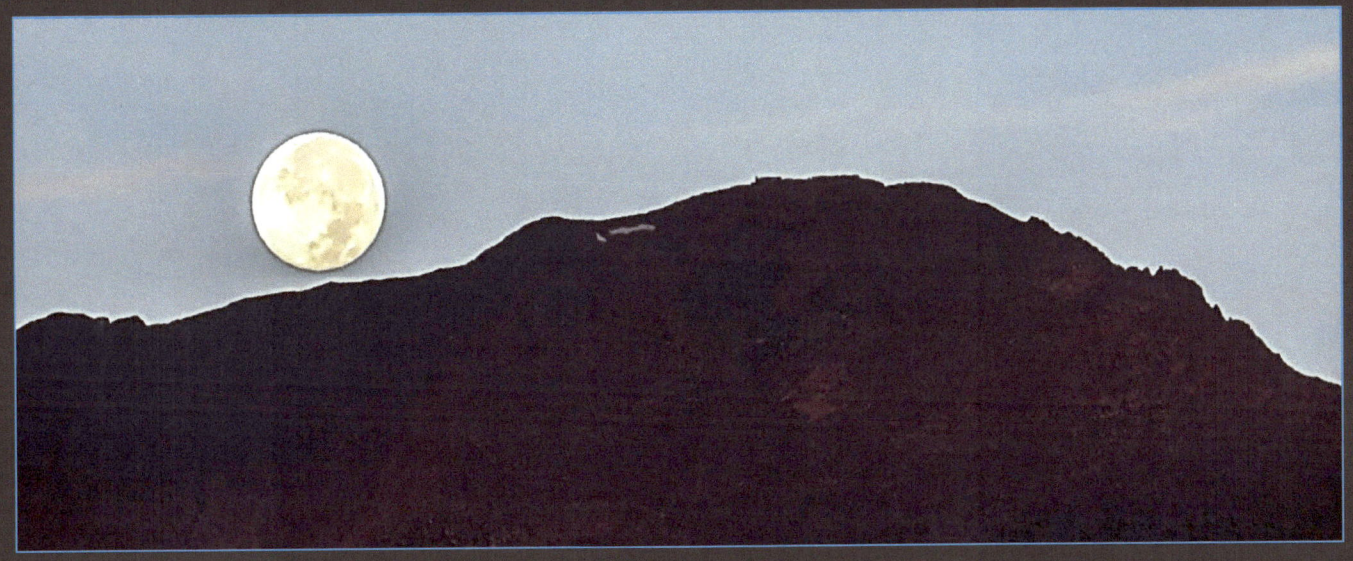
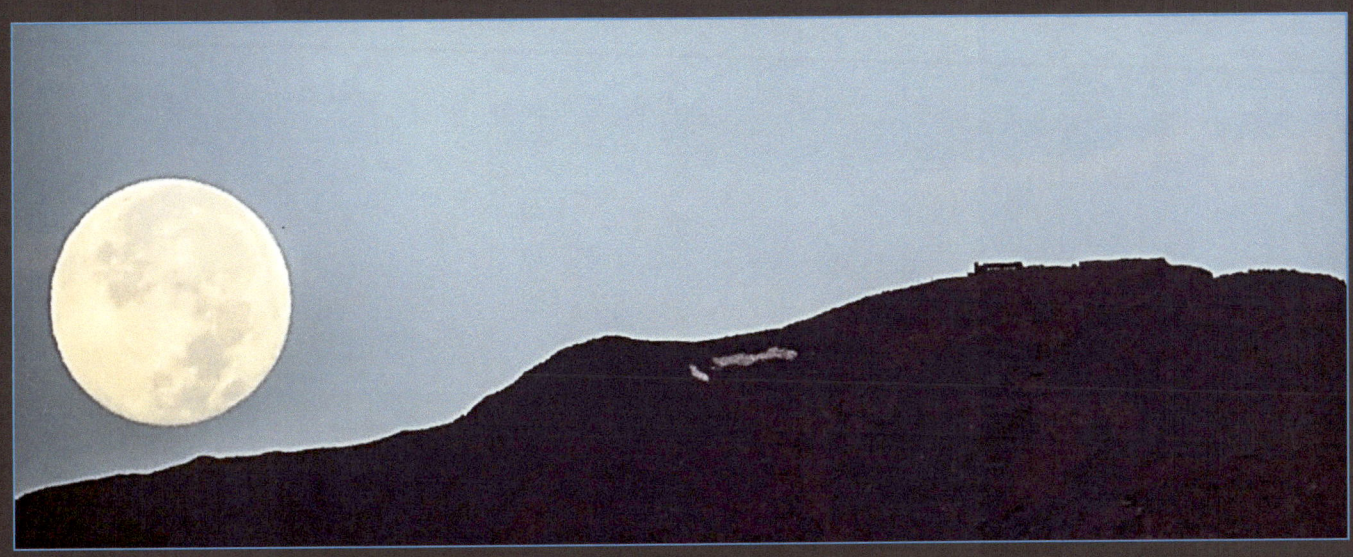

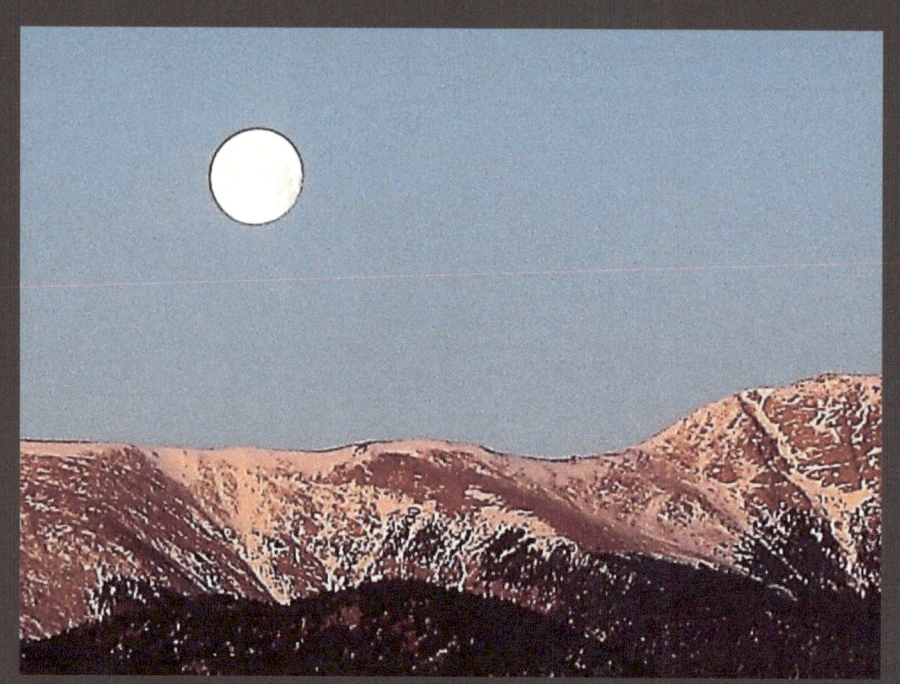
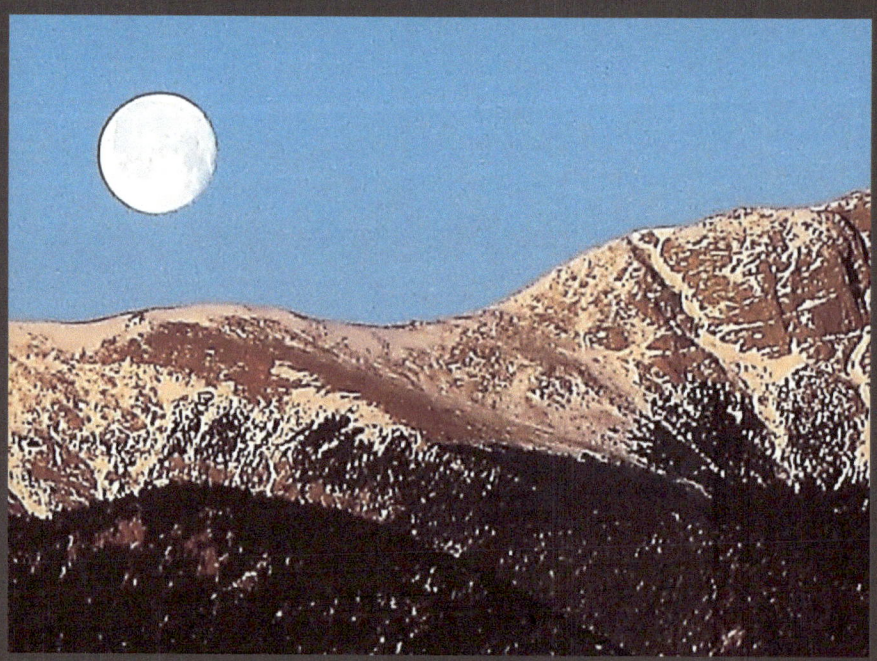

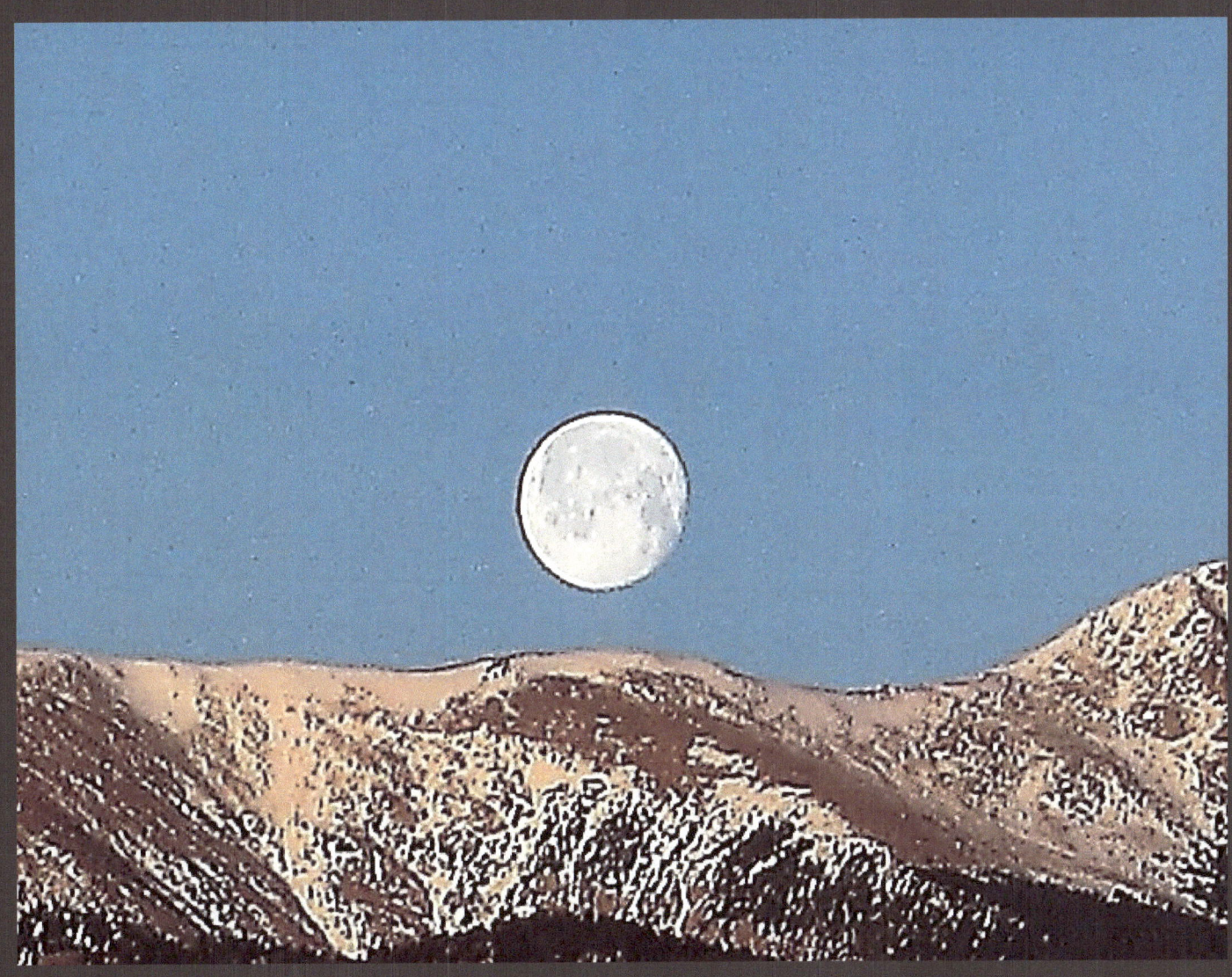

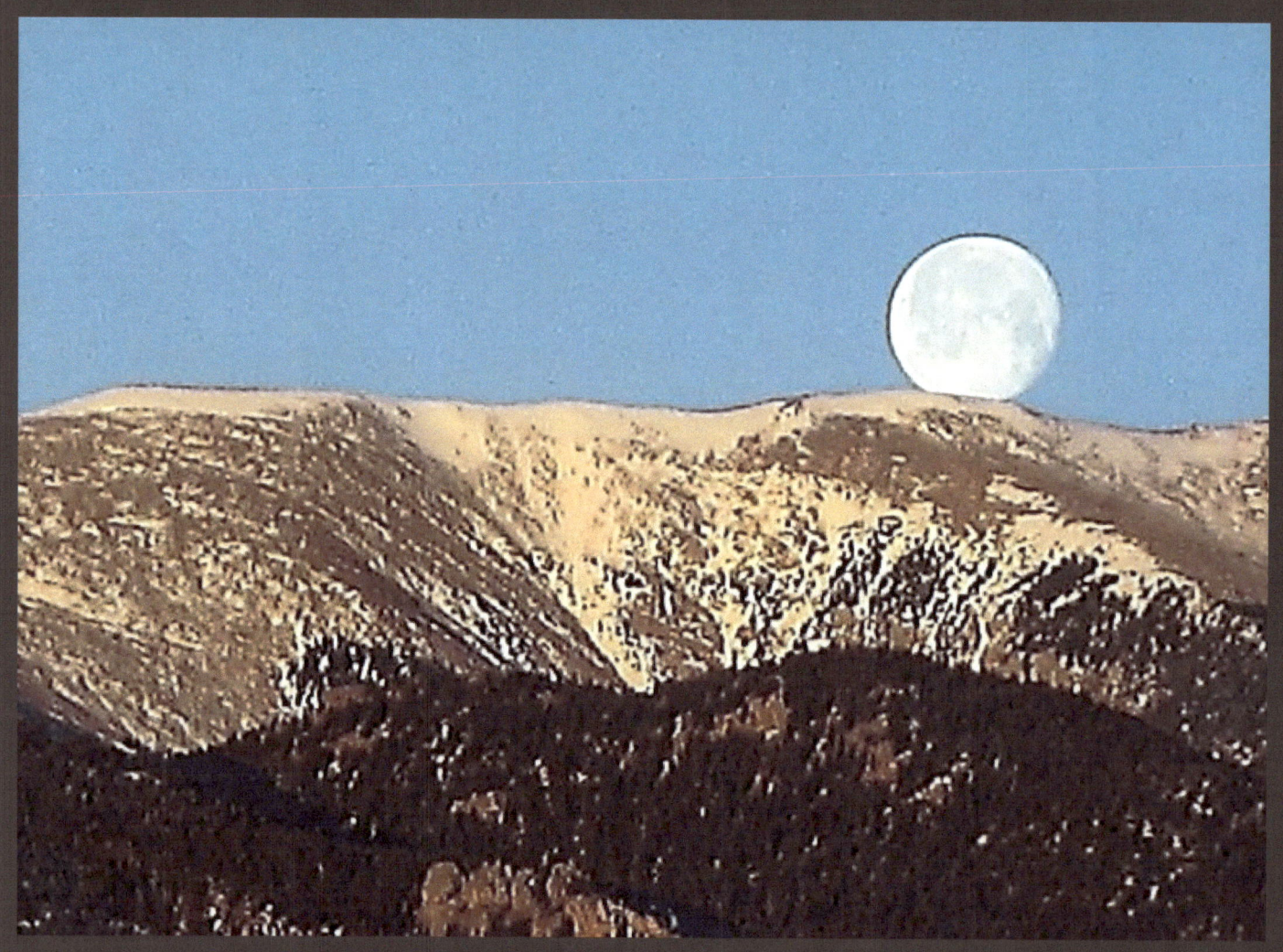

She might dance along the ridgeline for a while

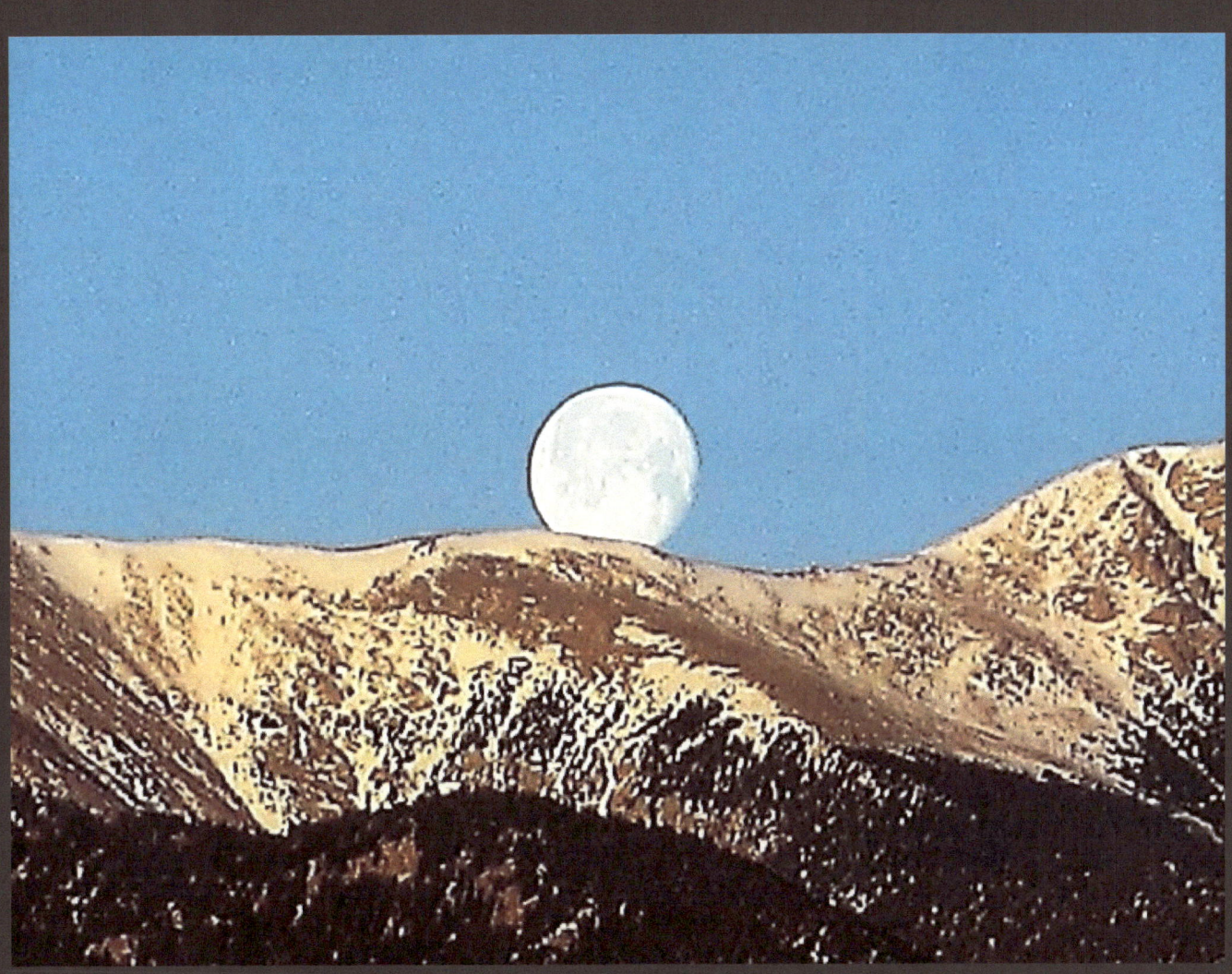

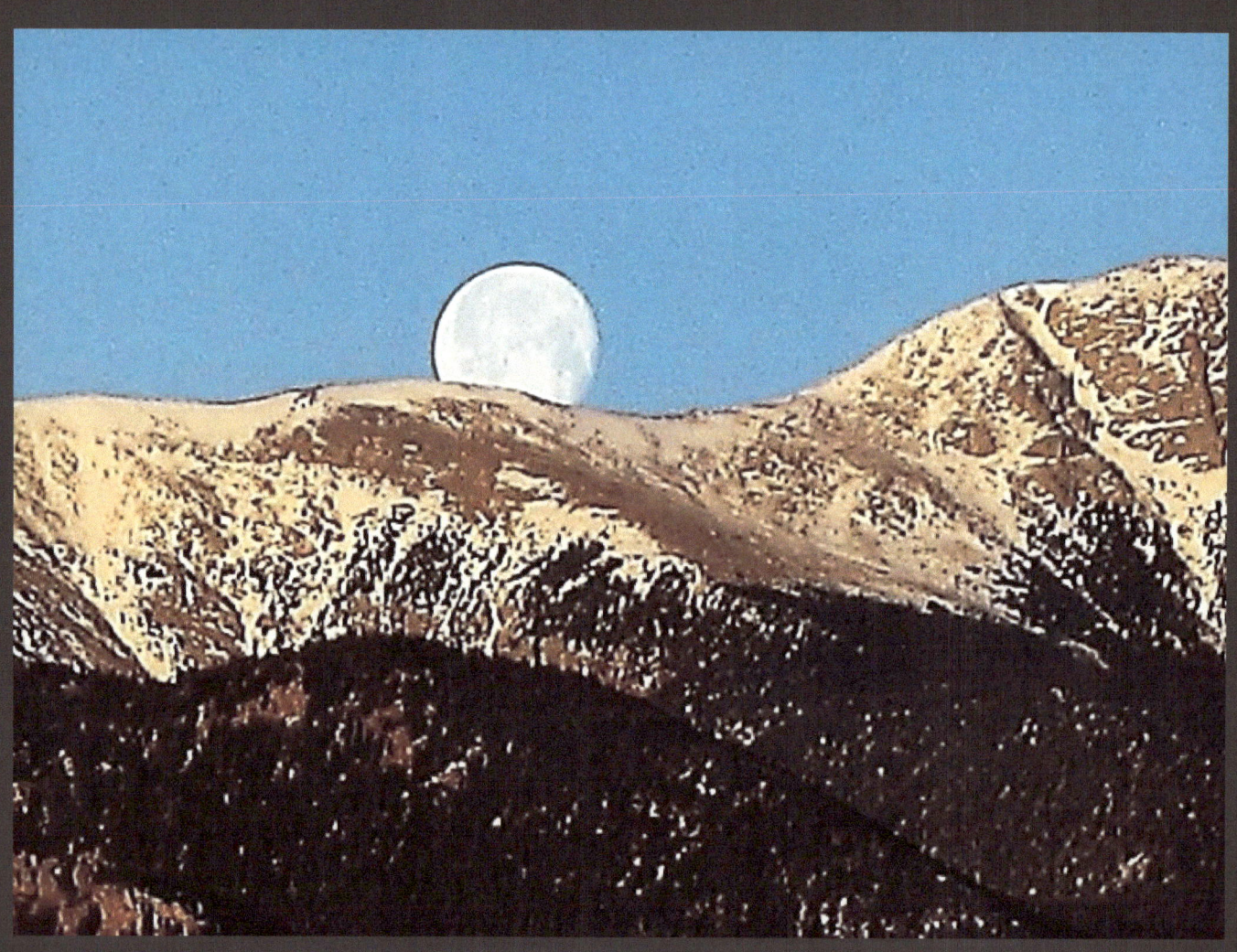

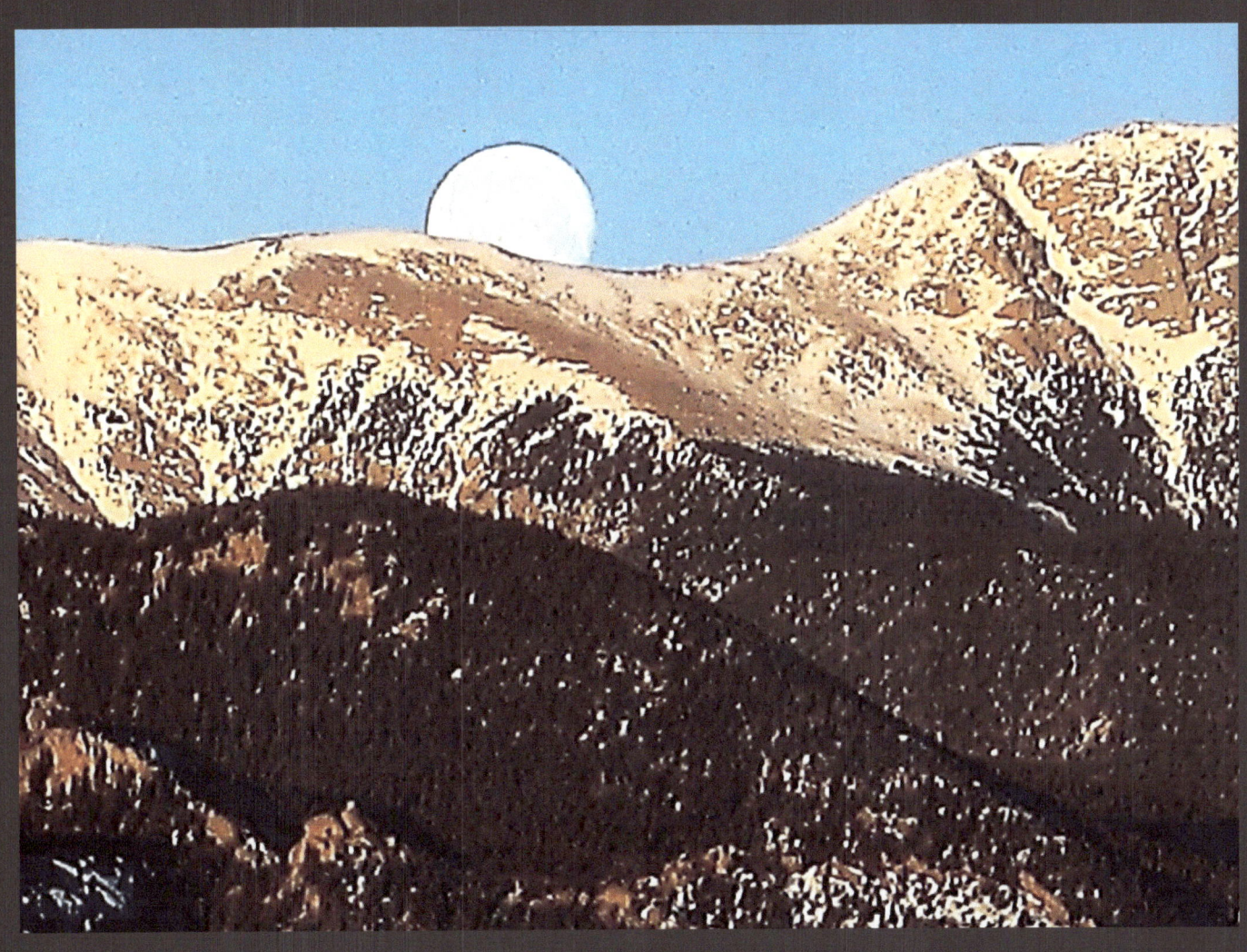

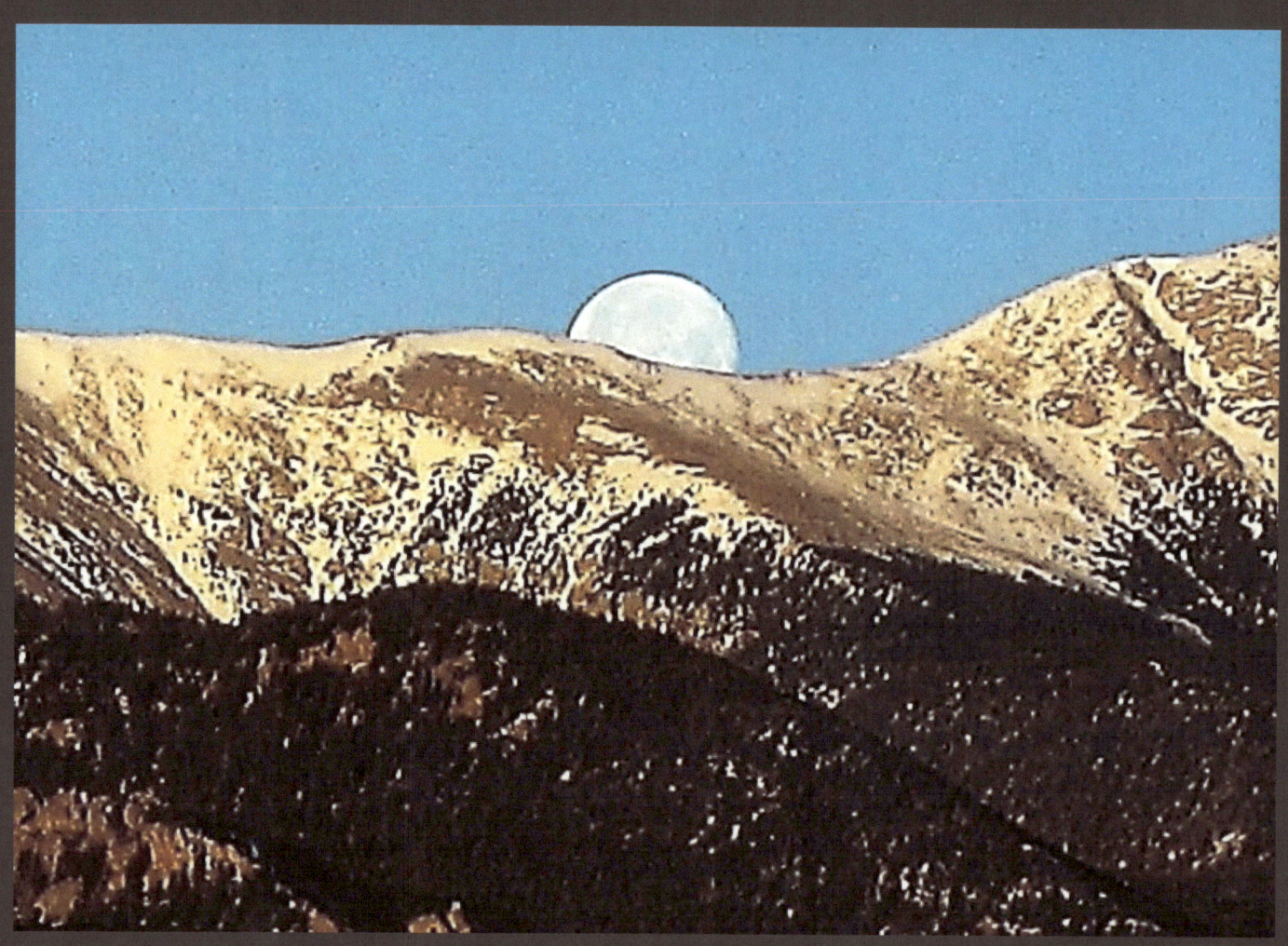

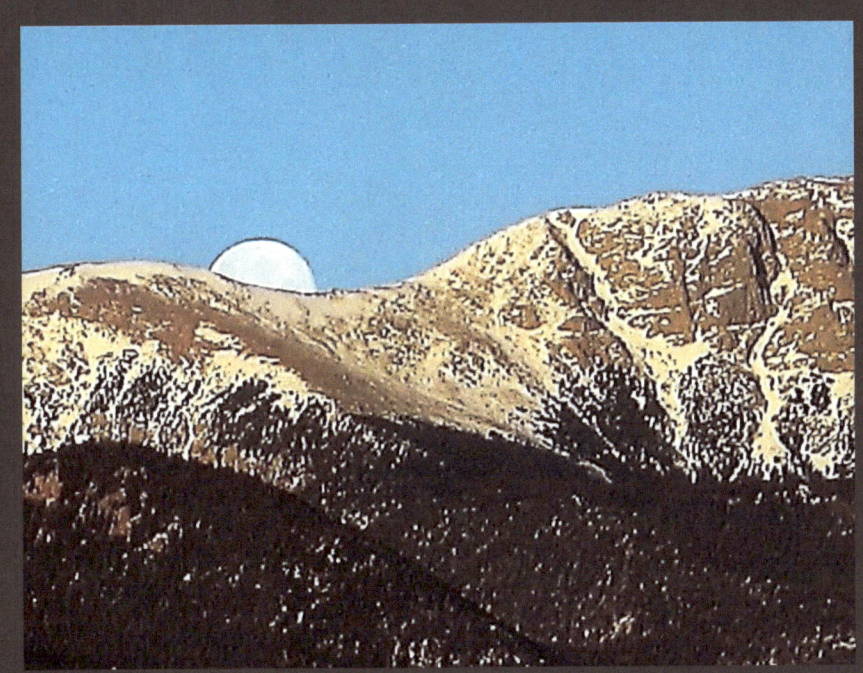

before slipping down
behind it.

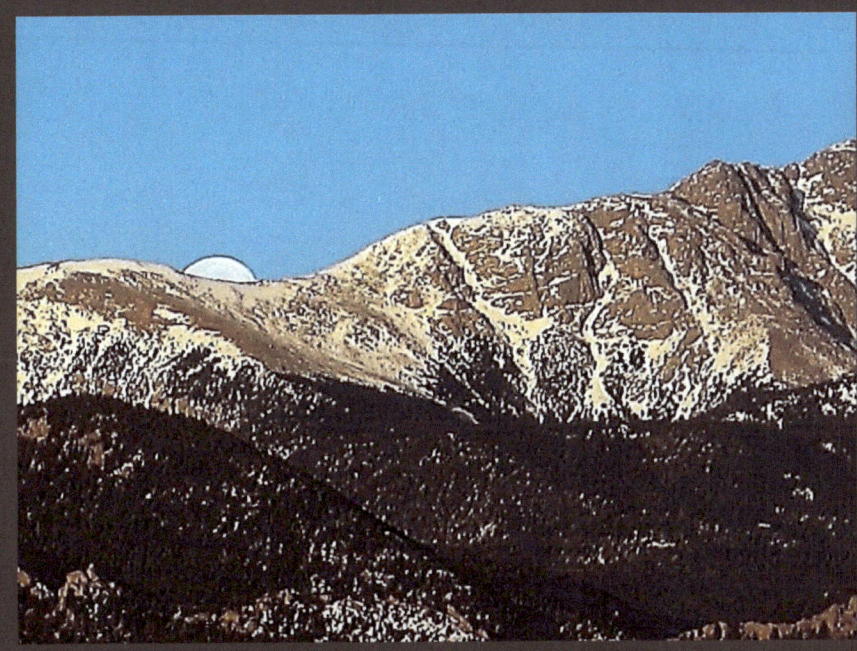

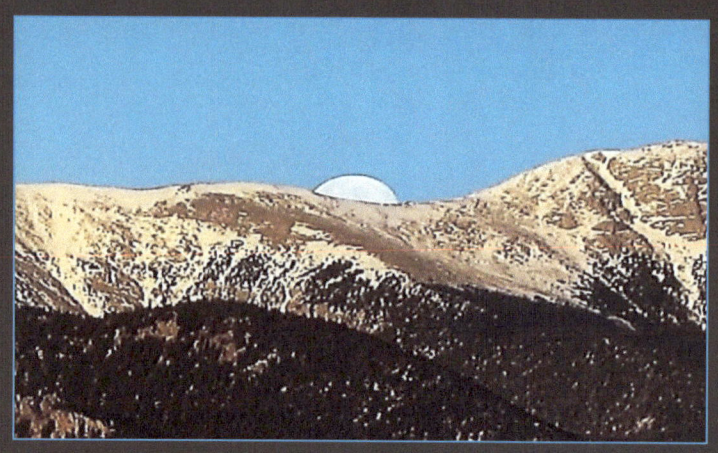
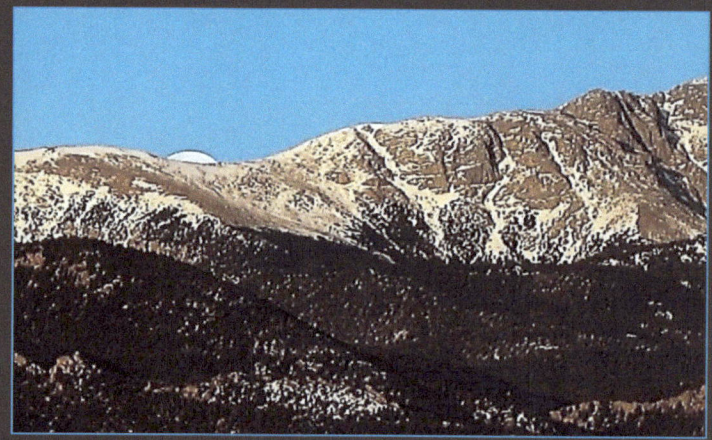
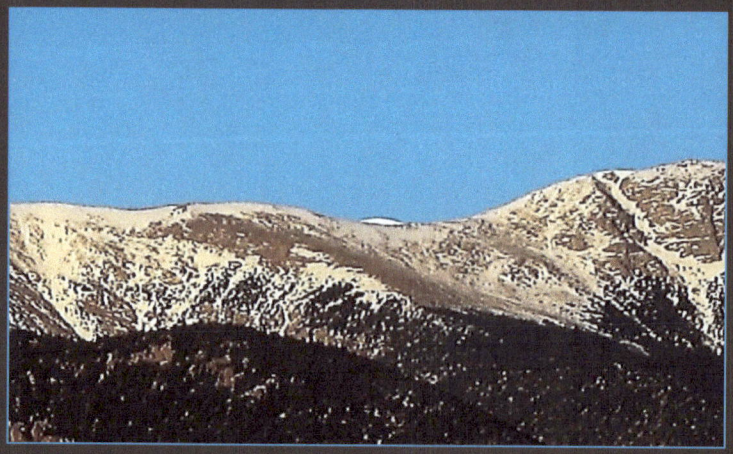

Let's see that once again.

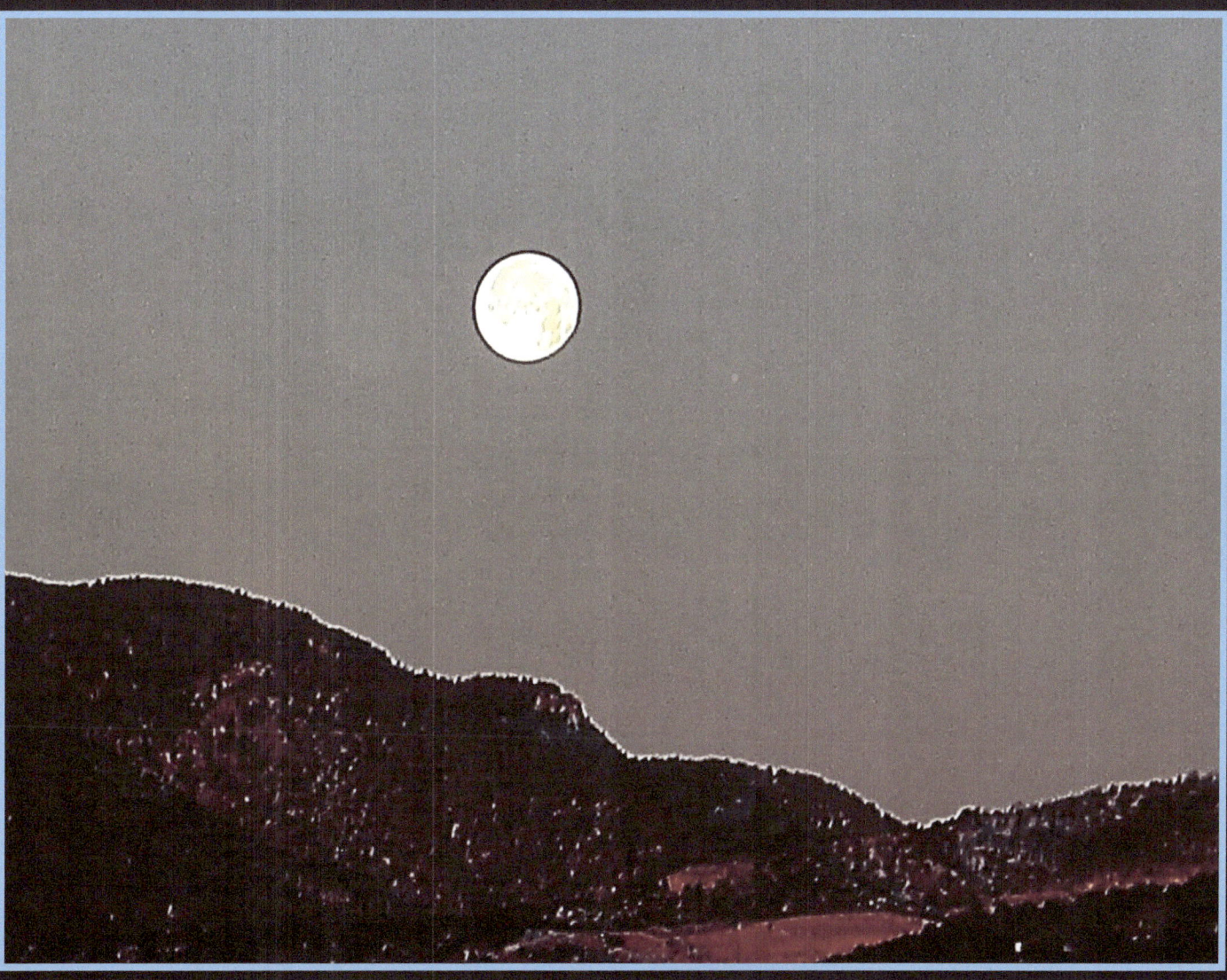

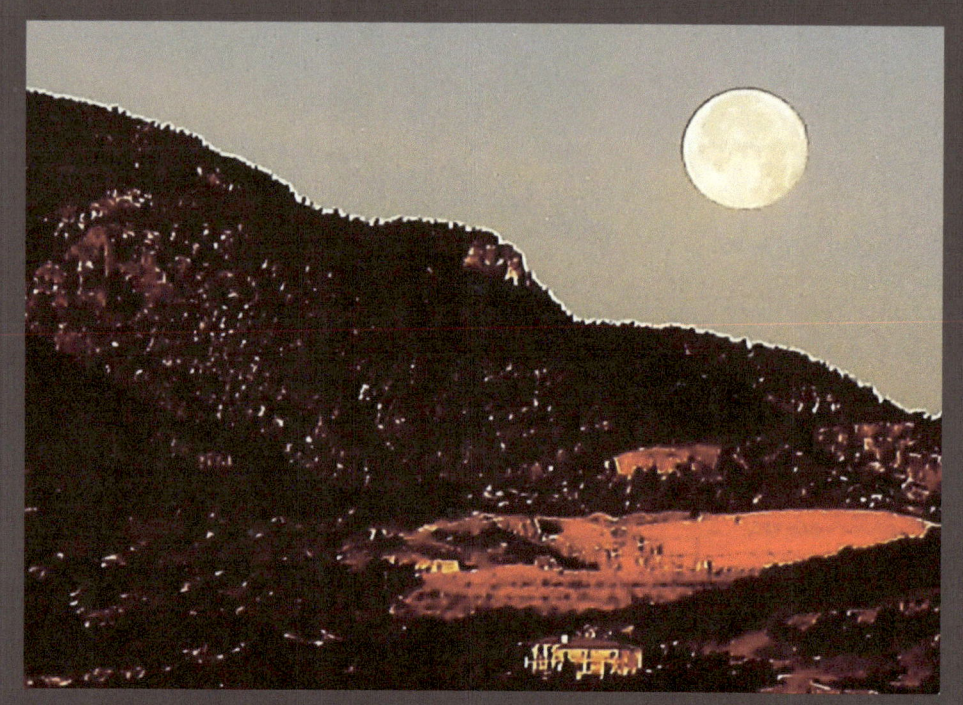
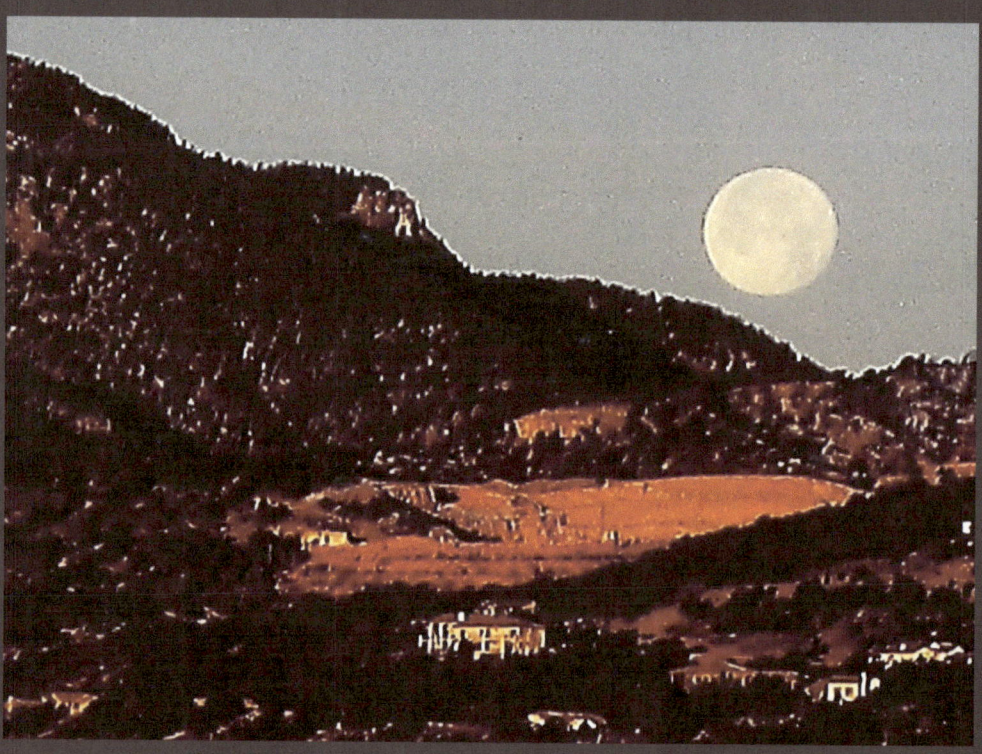

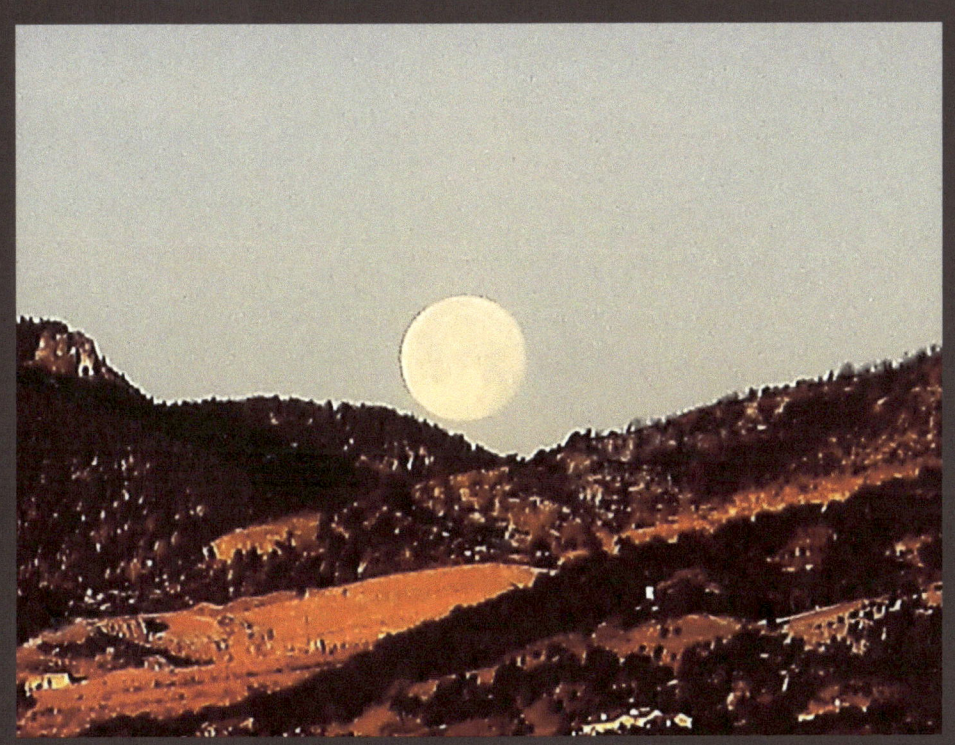
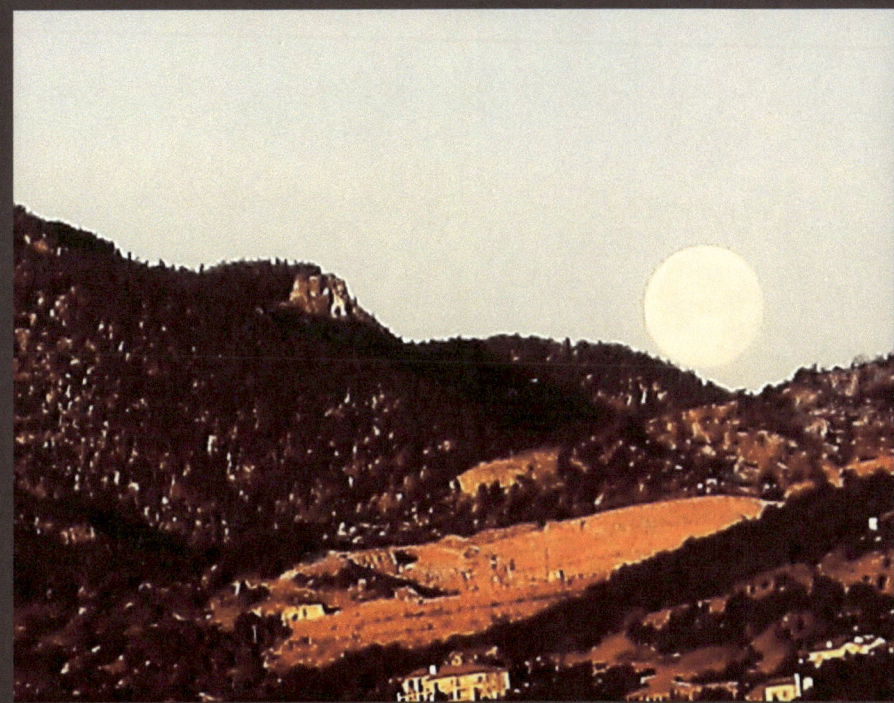

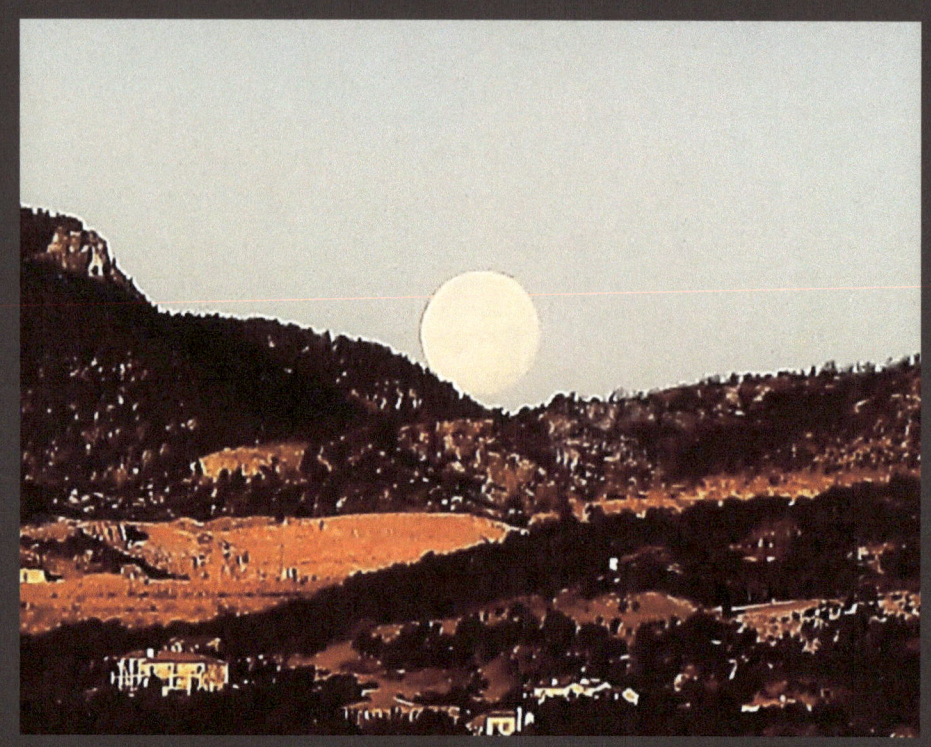
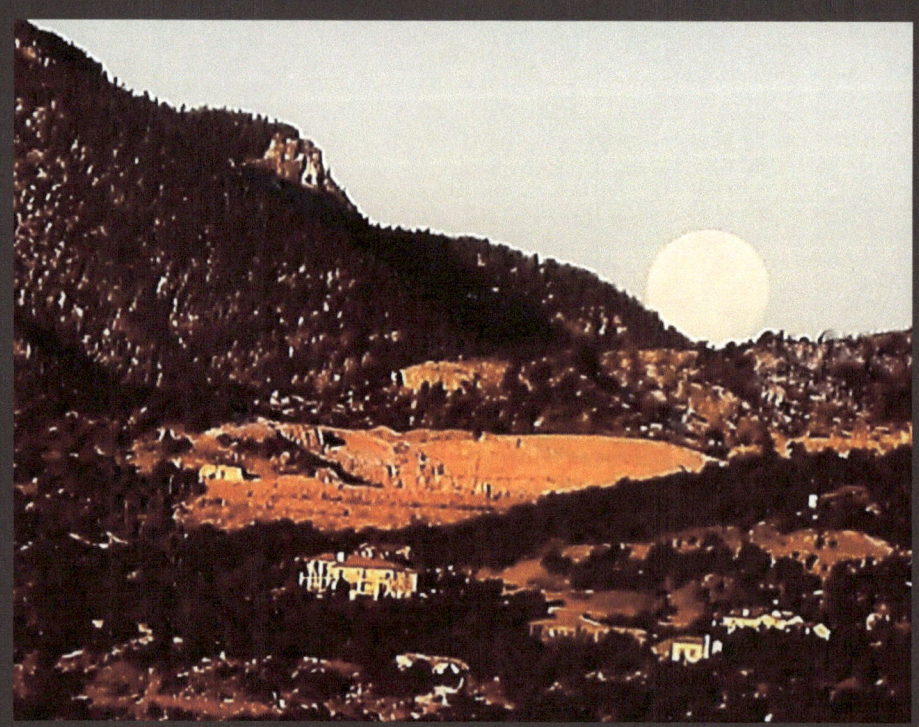

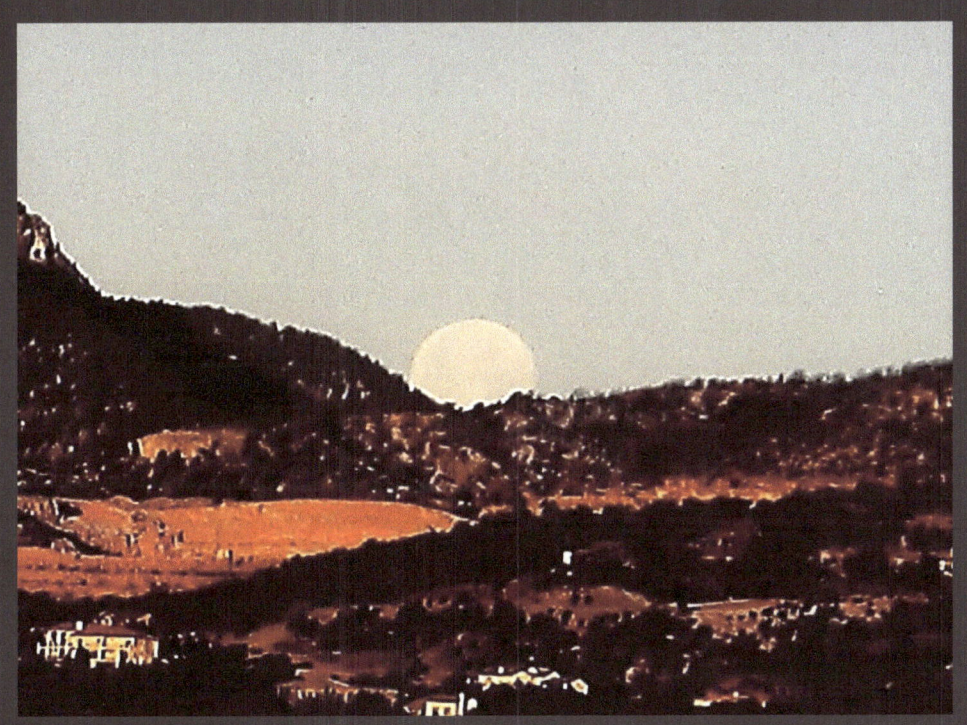
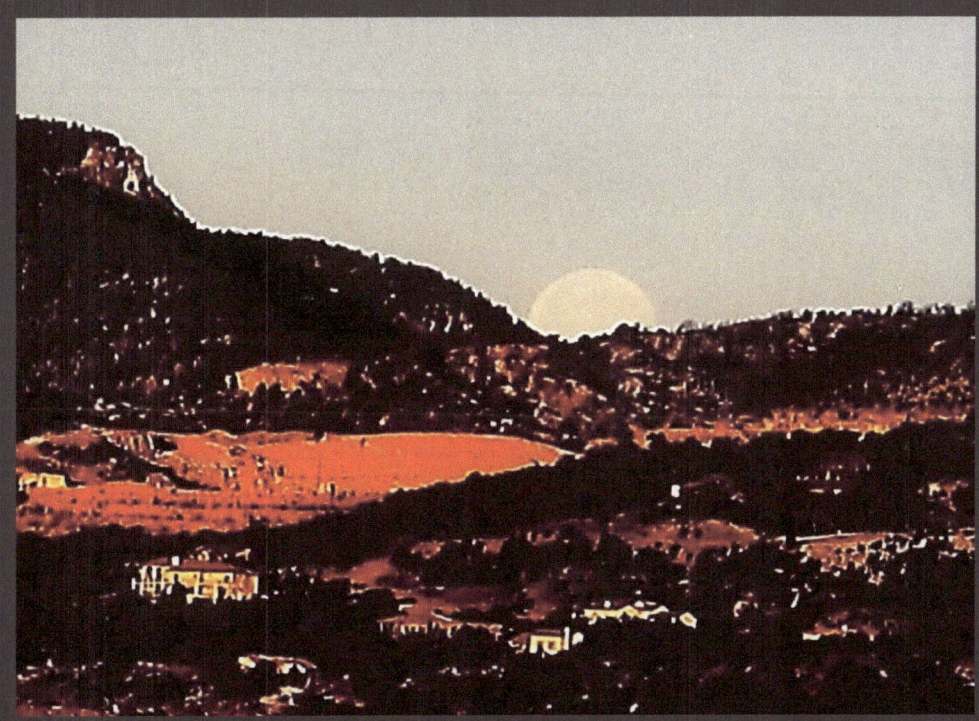

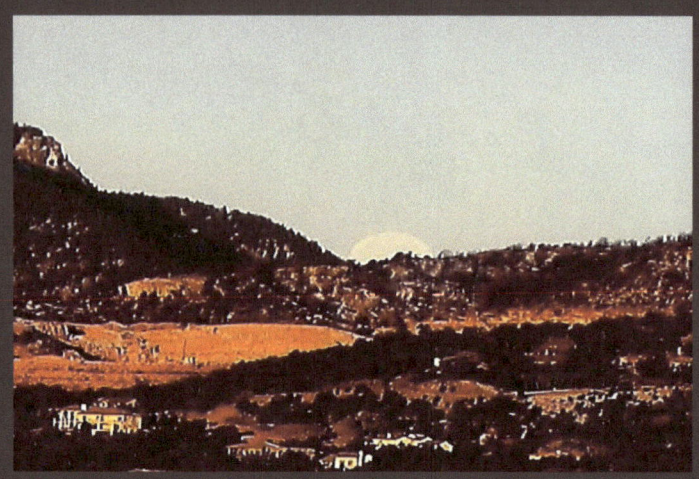

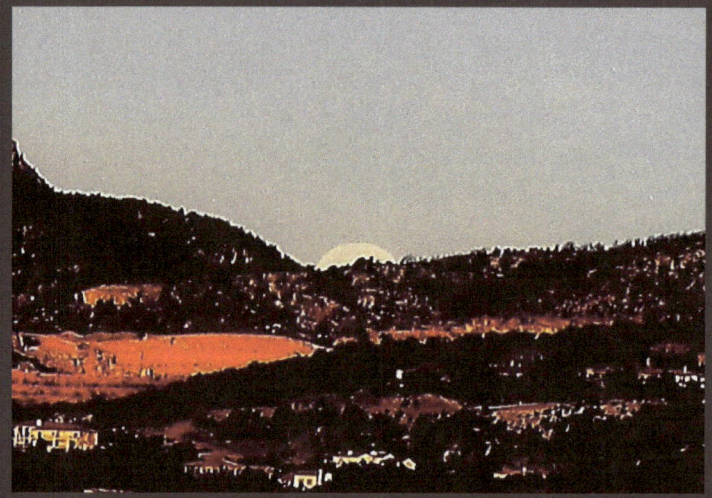

A collective sigh
trails
behind her
setting.

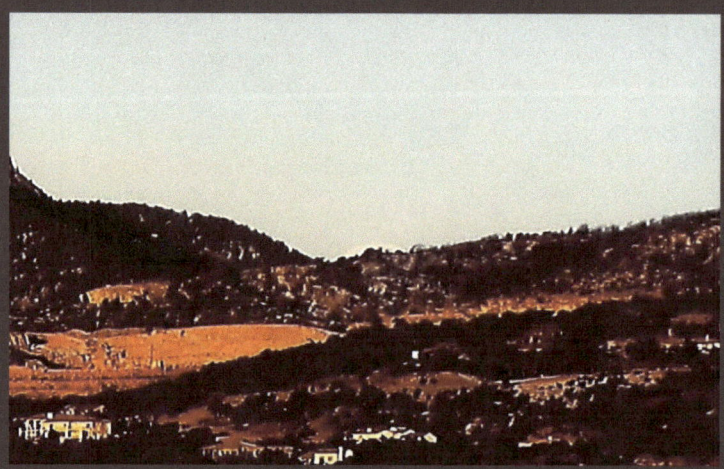

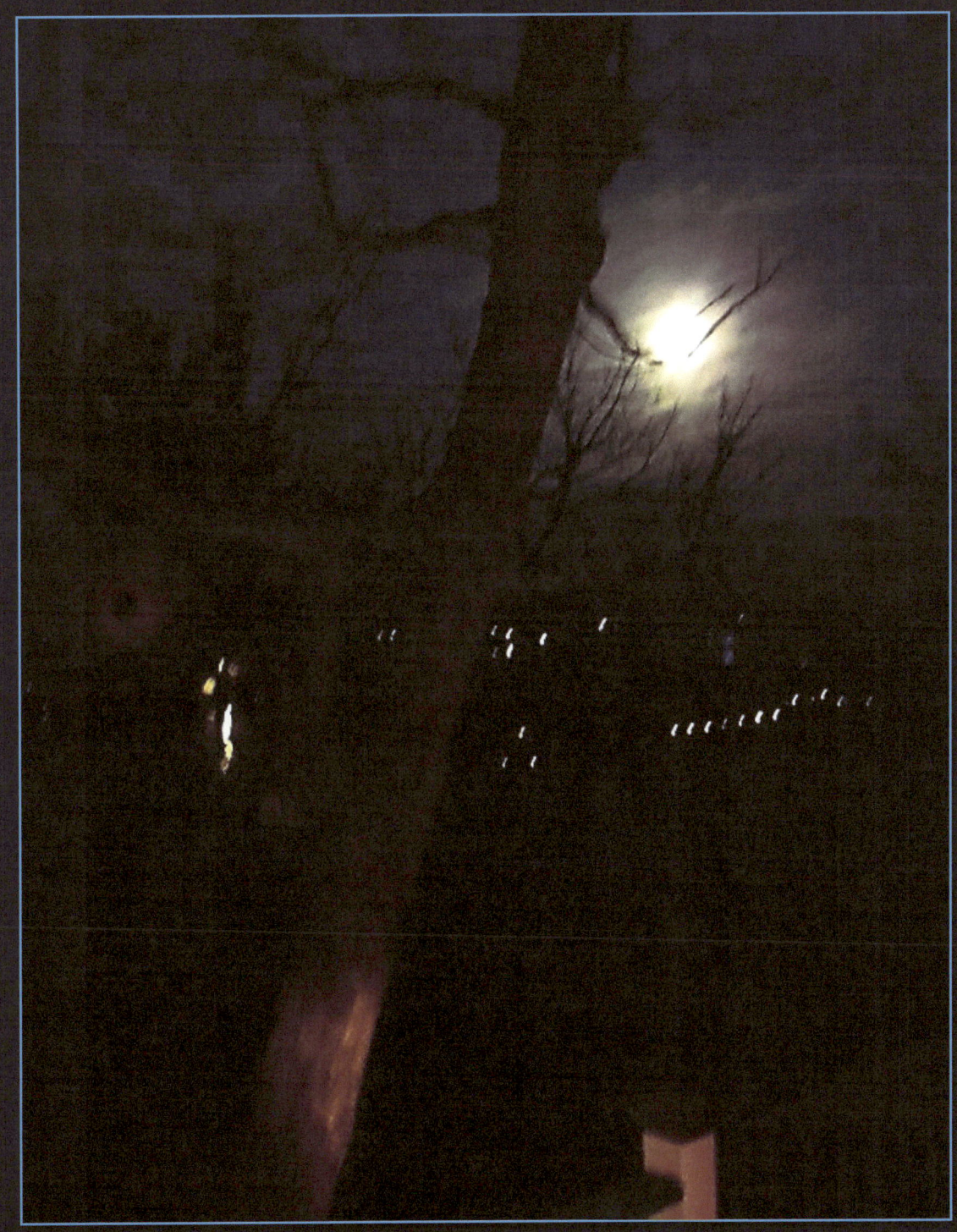

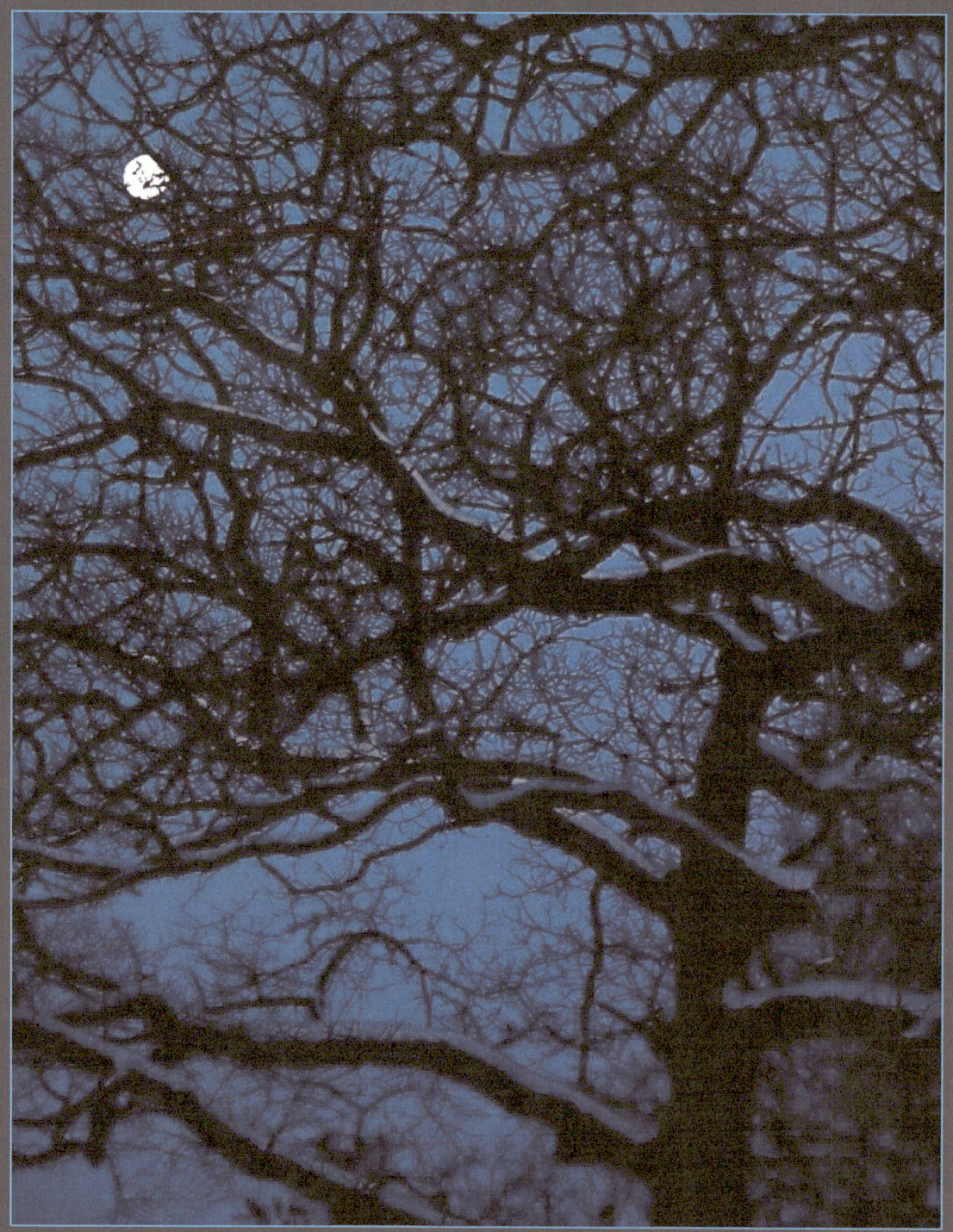

We sleep under her waxing and waning,

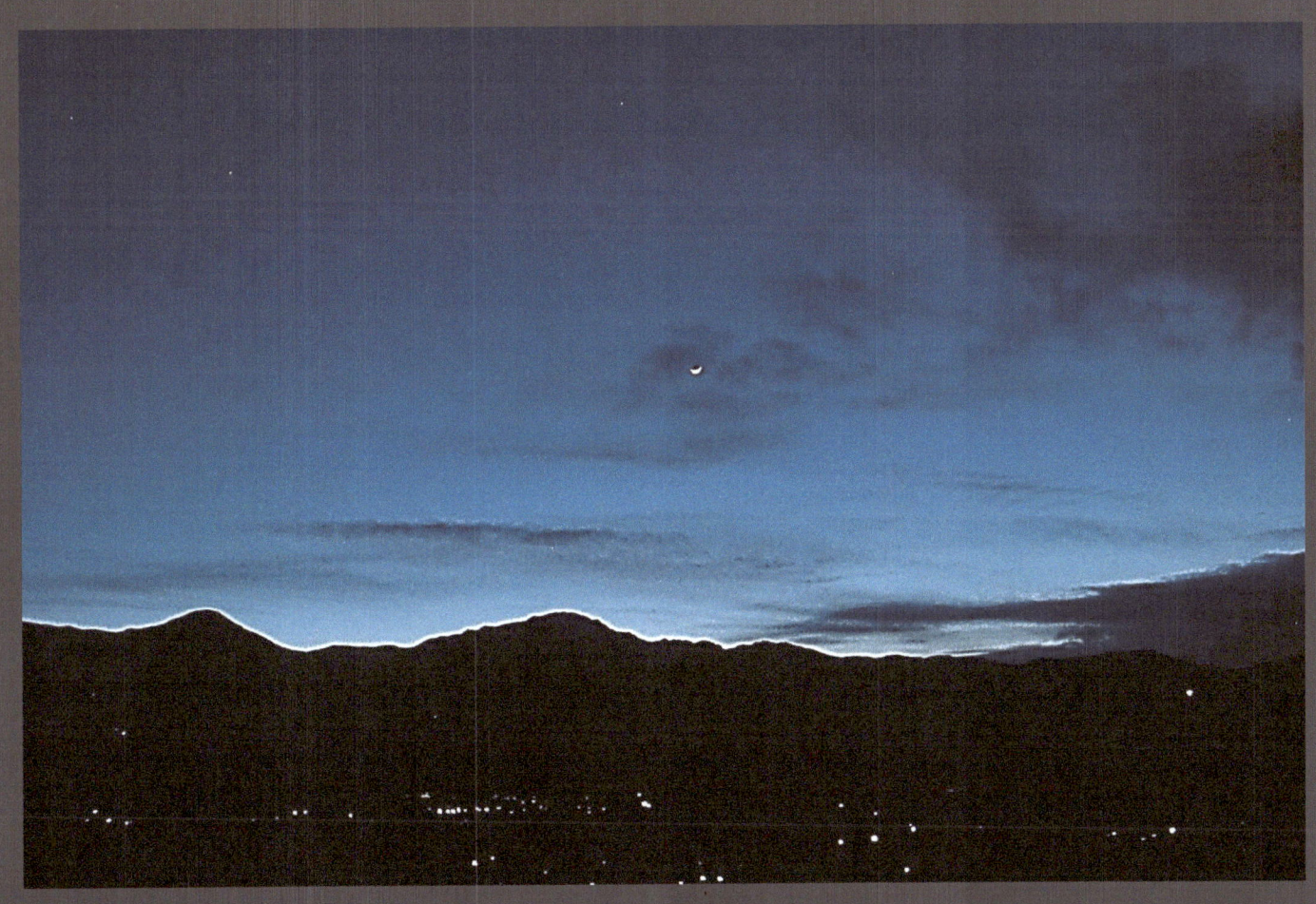

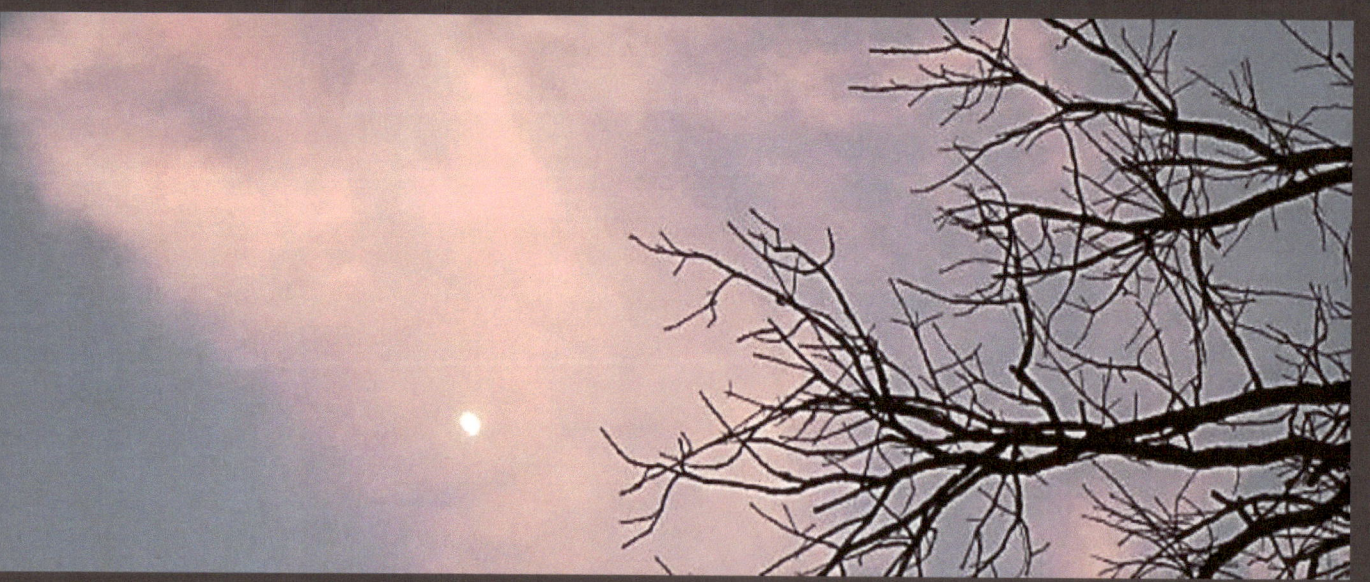

soothed as she fashions the tides.

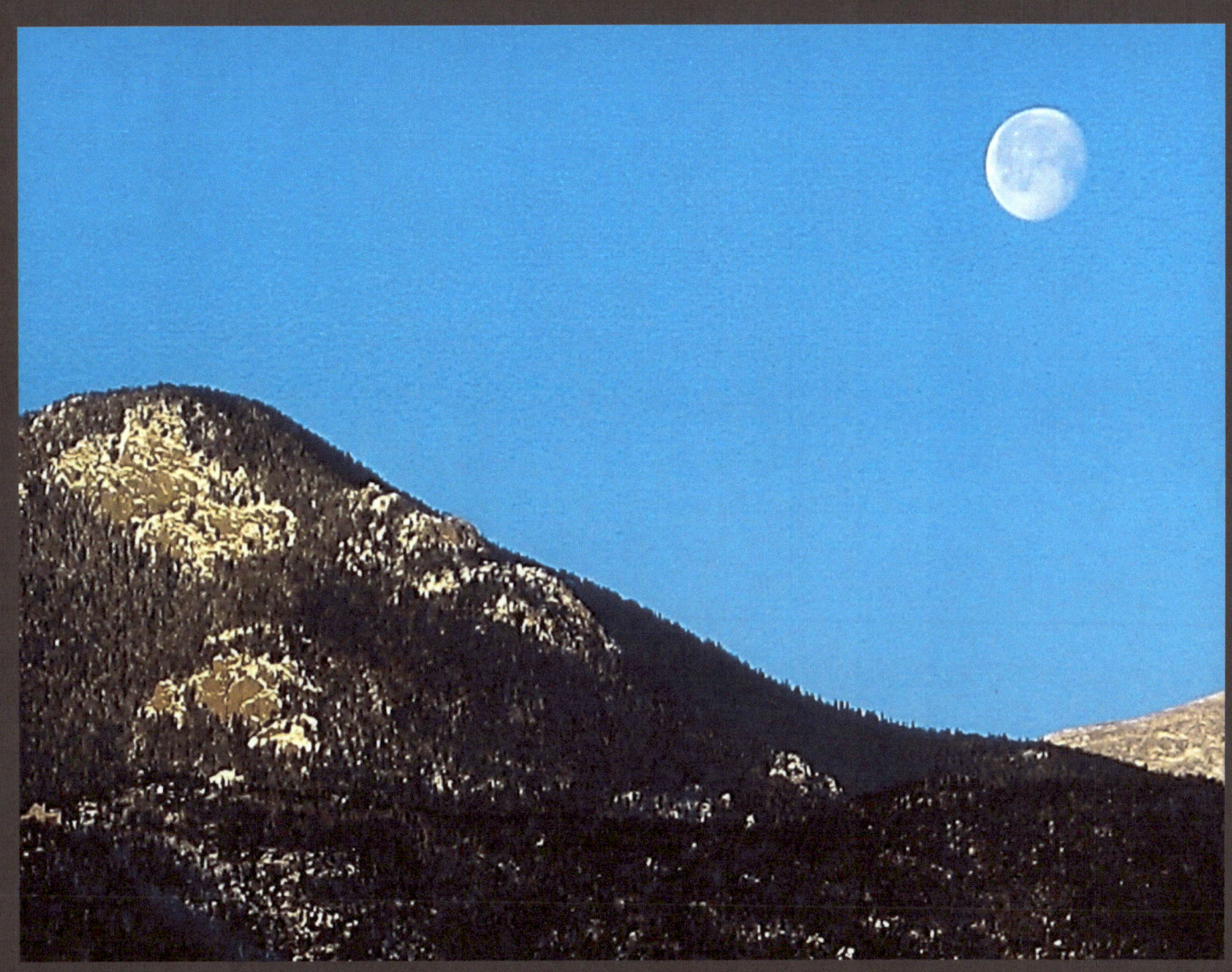

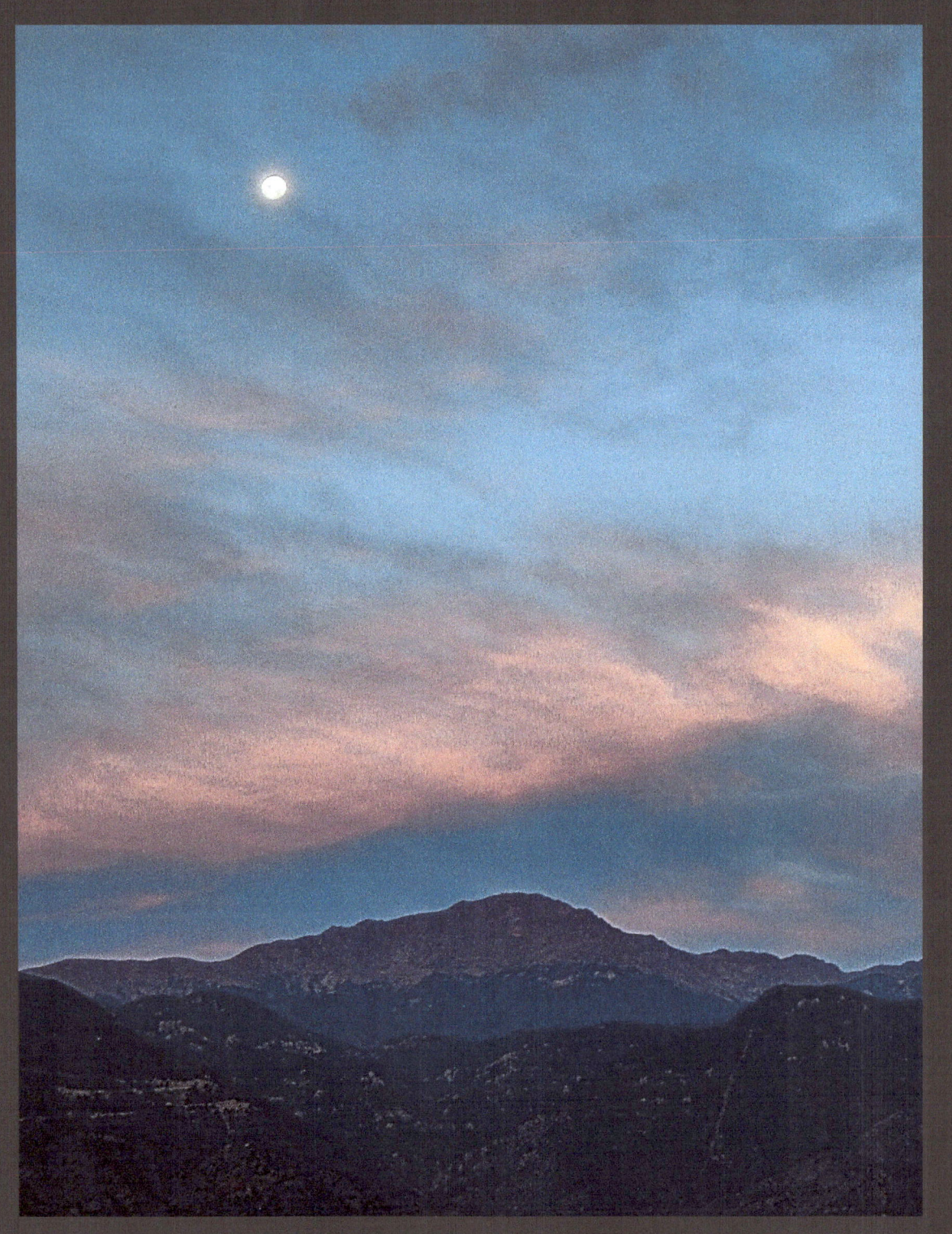

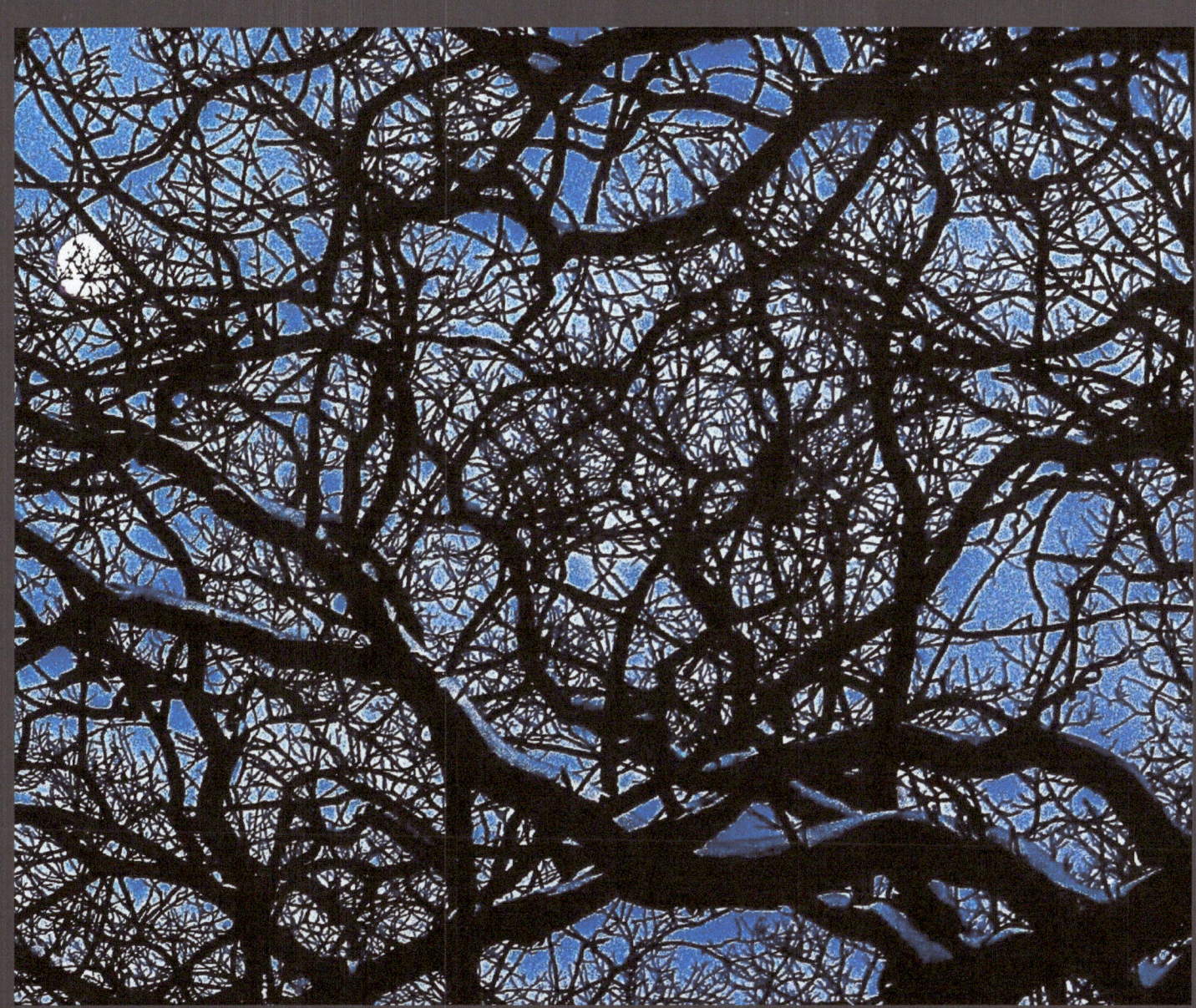

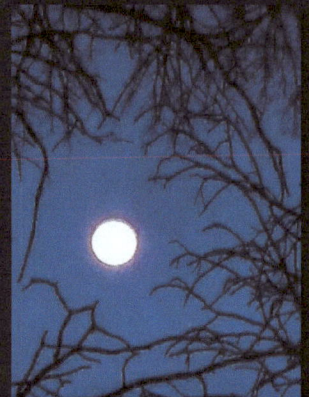

Throughout the world, primitive arms reach out to her.

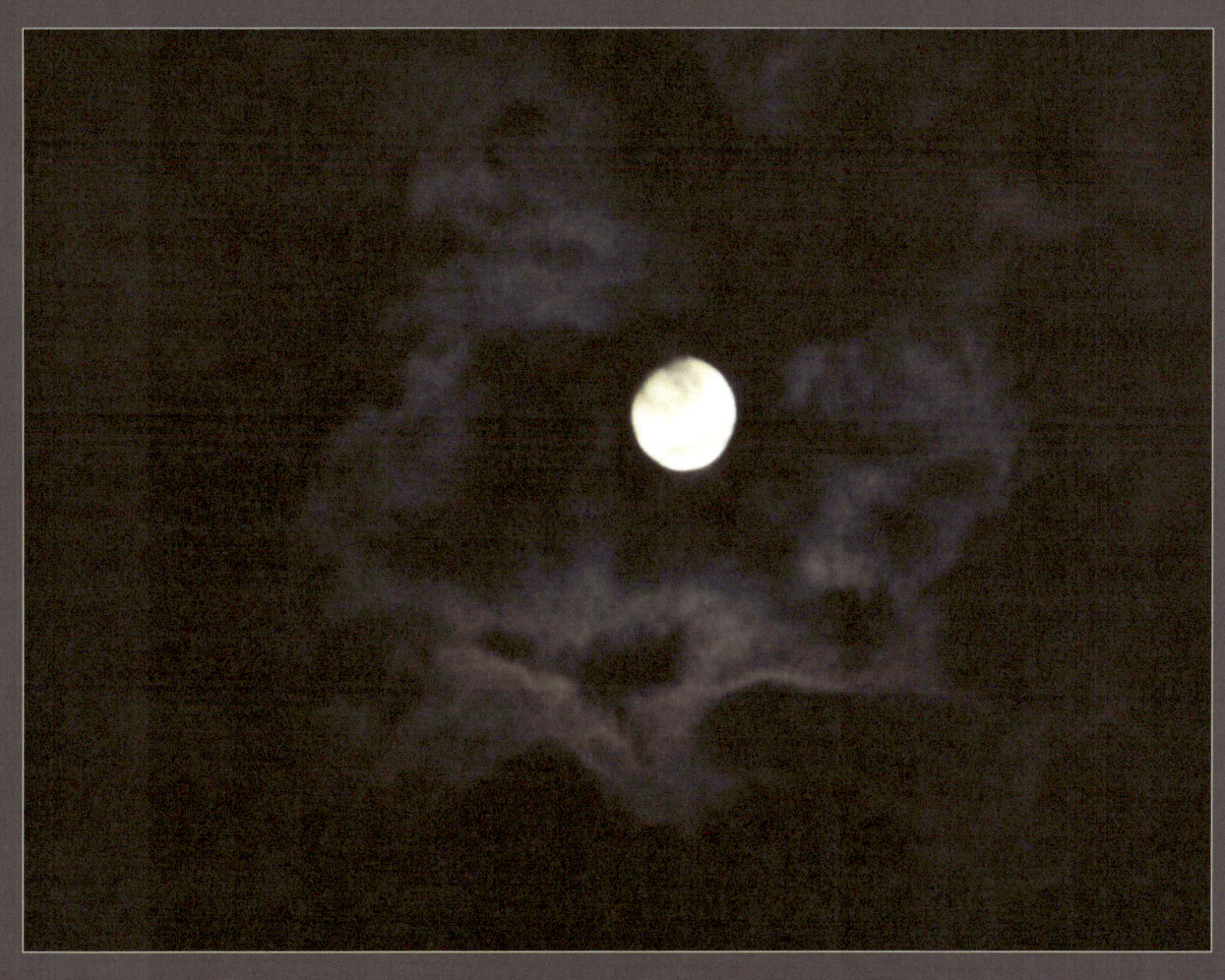

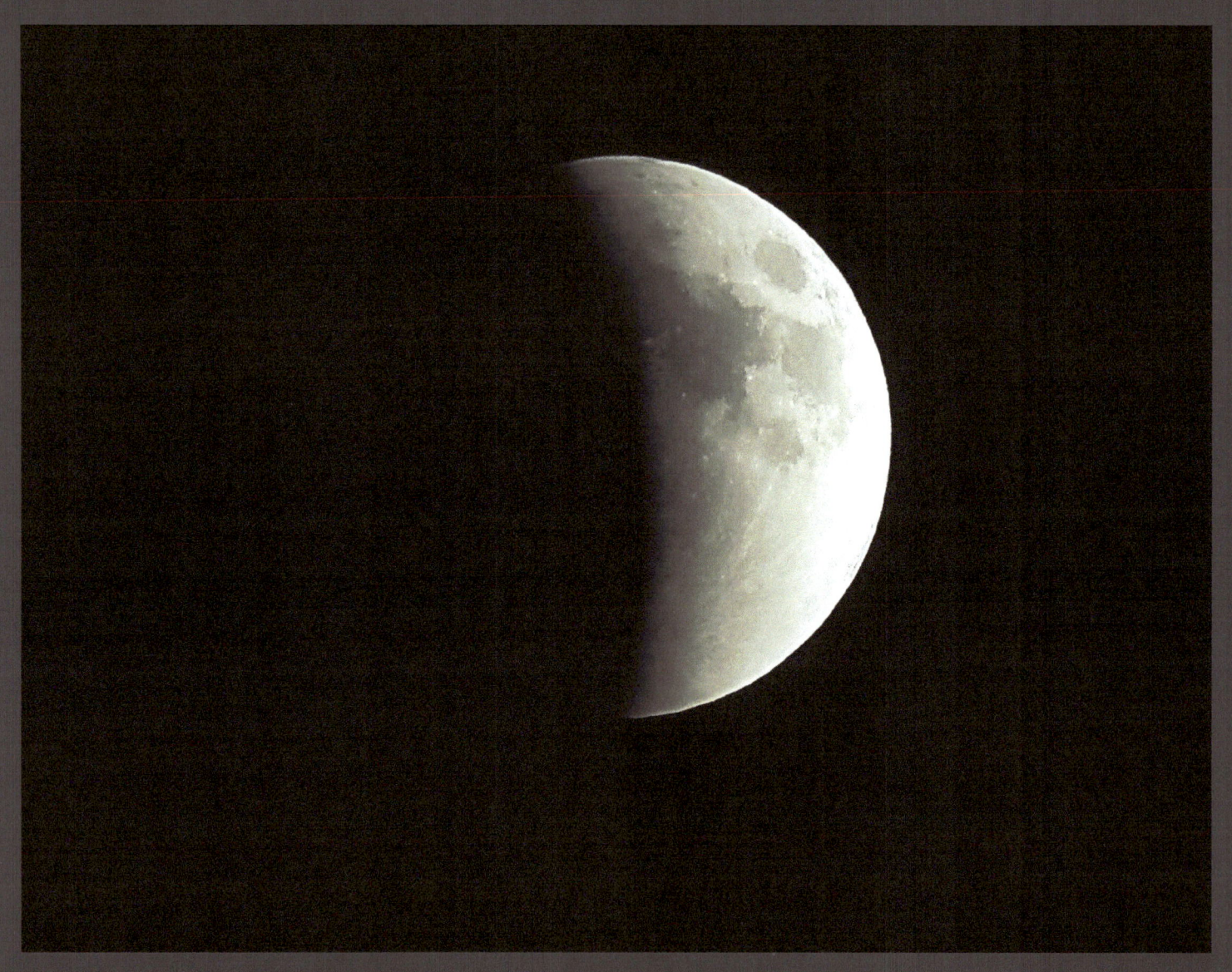

Occasionally a blood moon occurs.

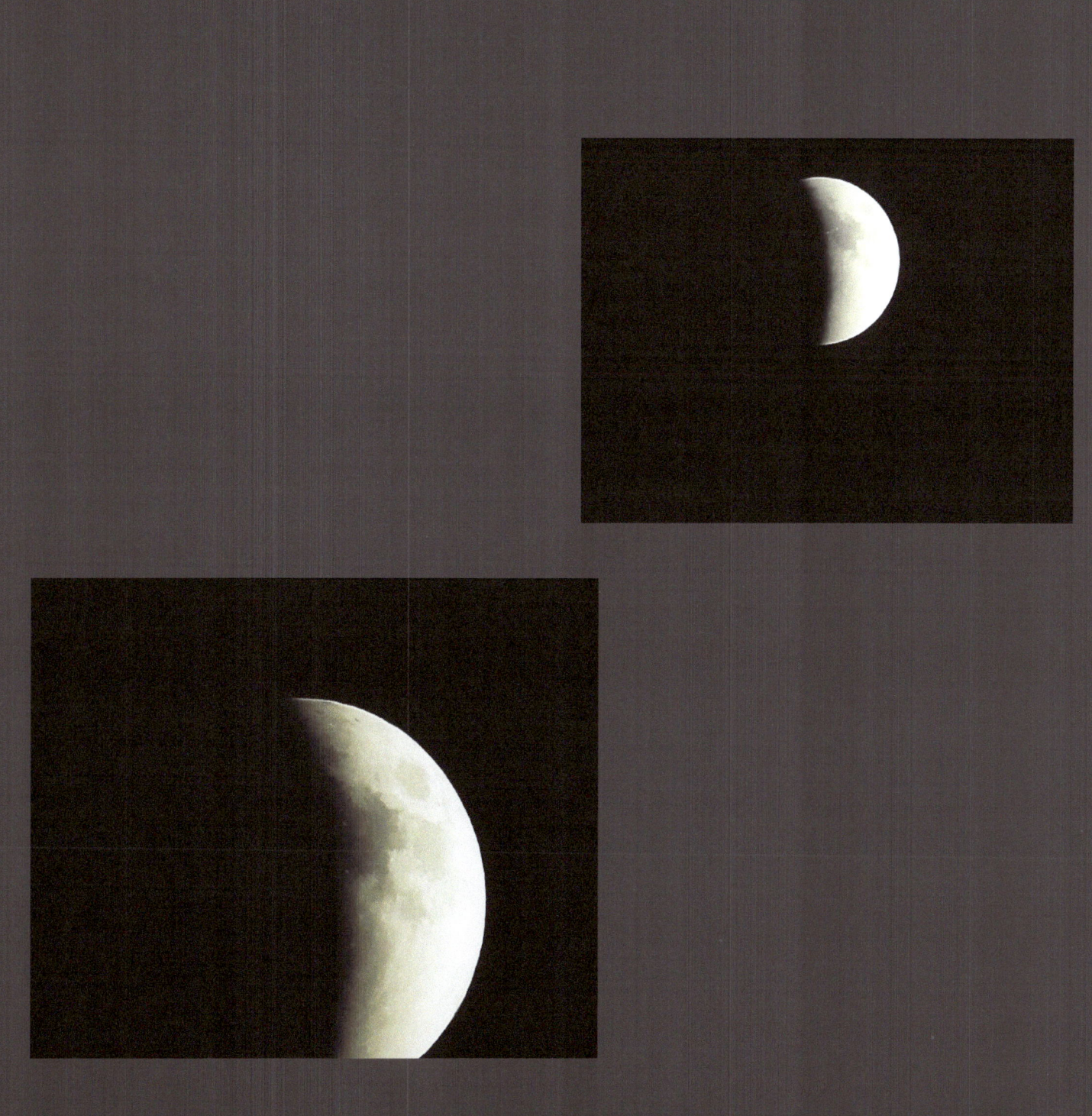

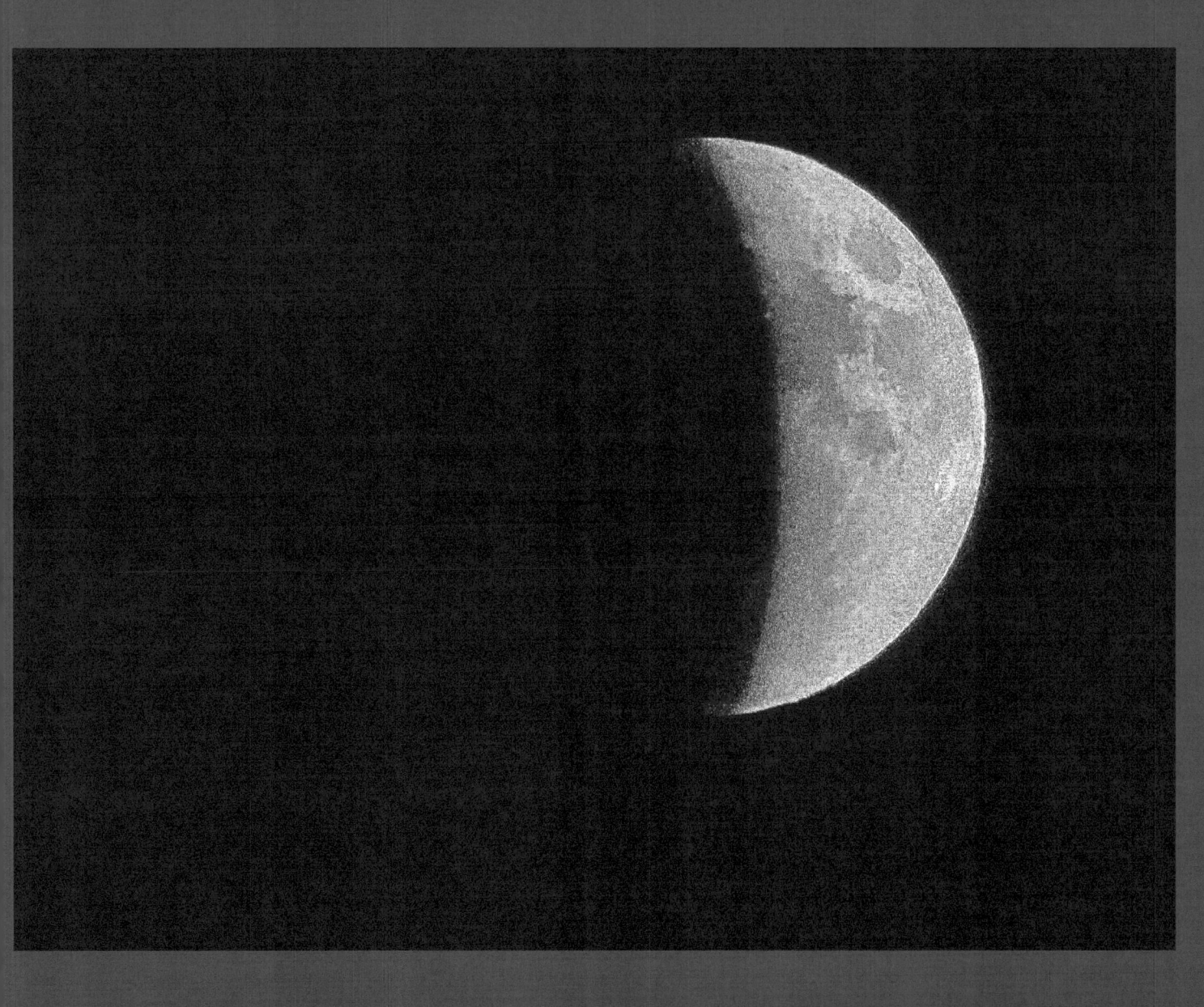

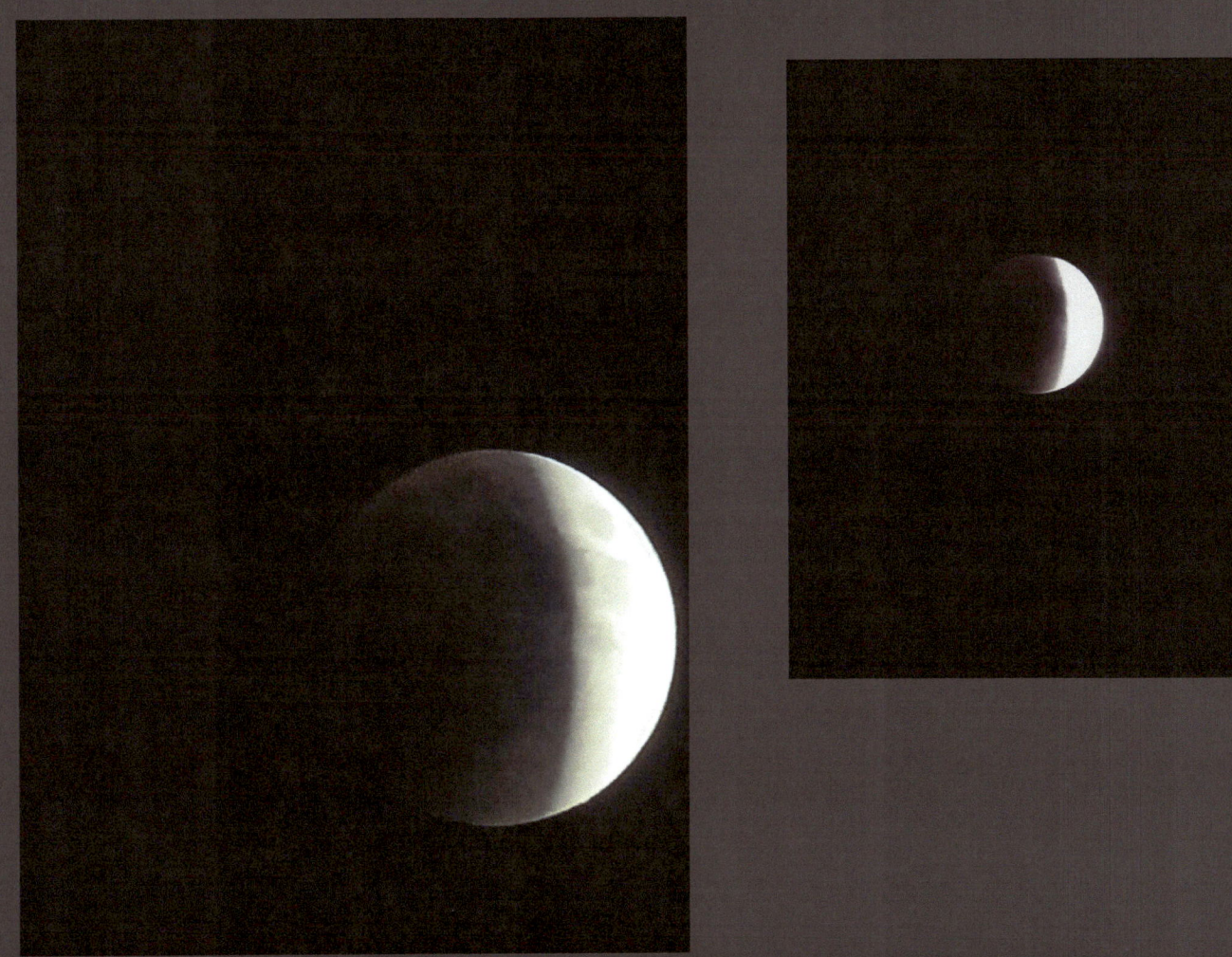

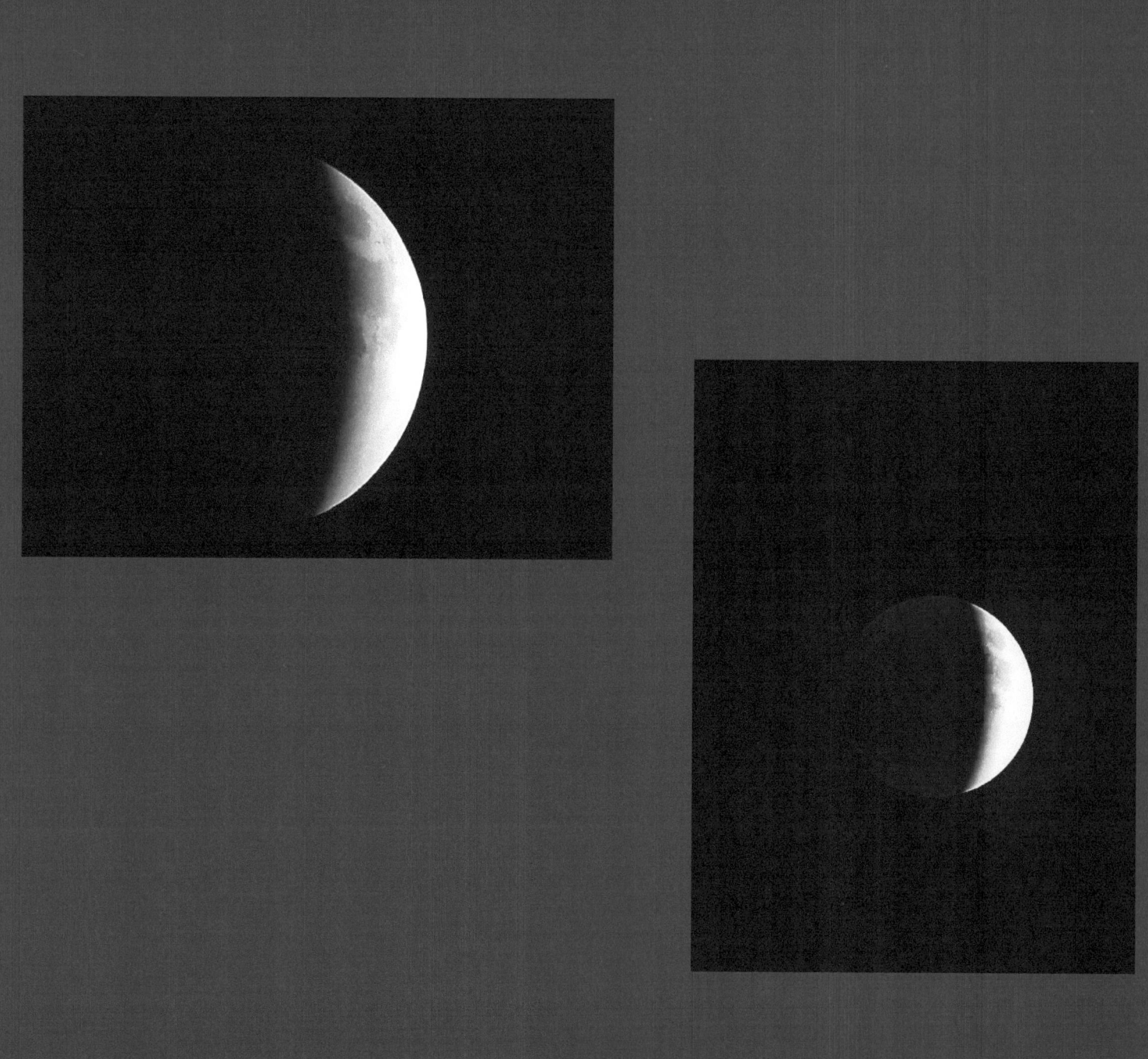

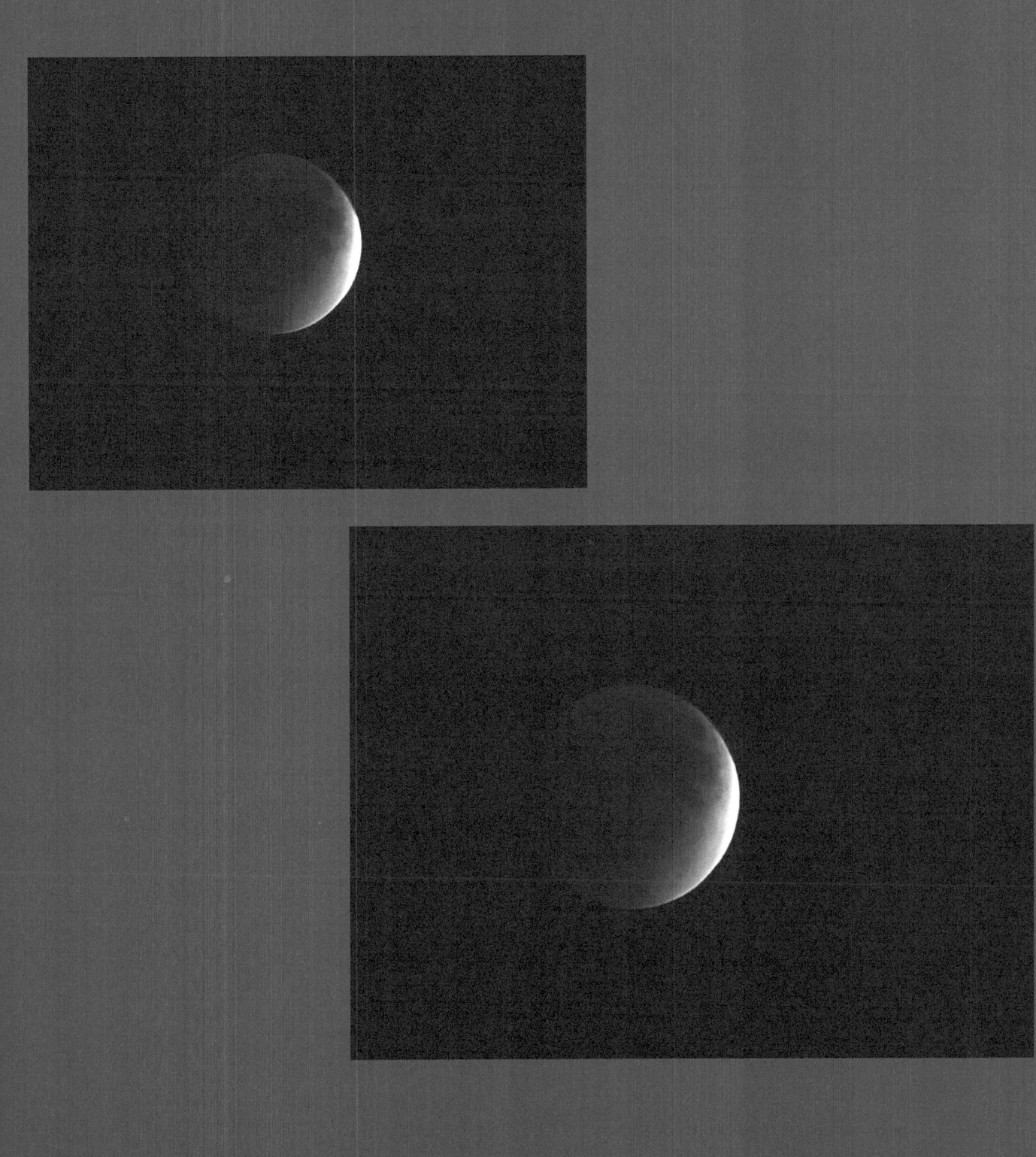

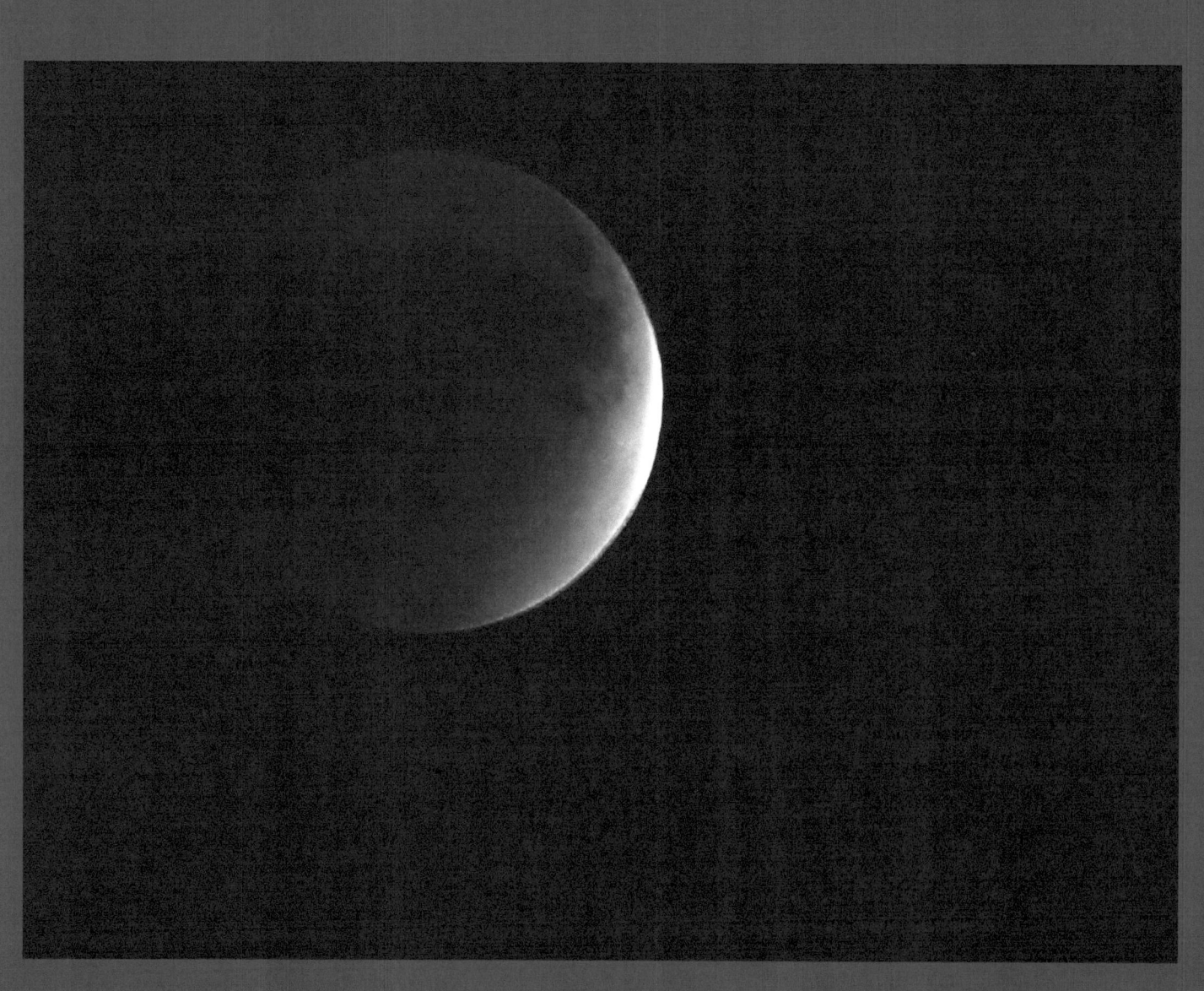

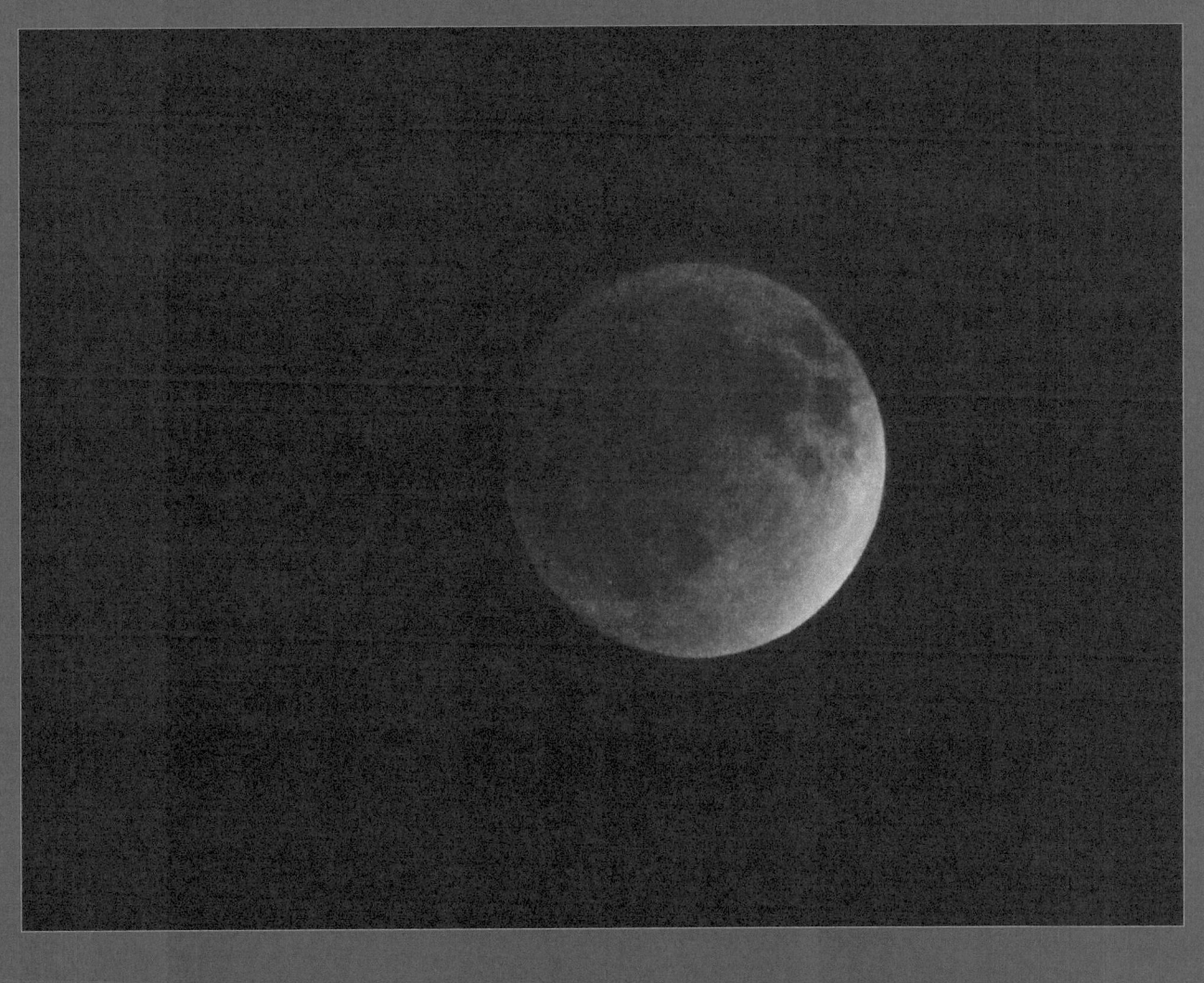

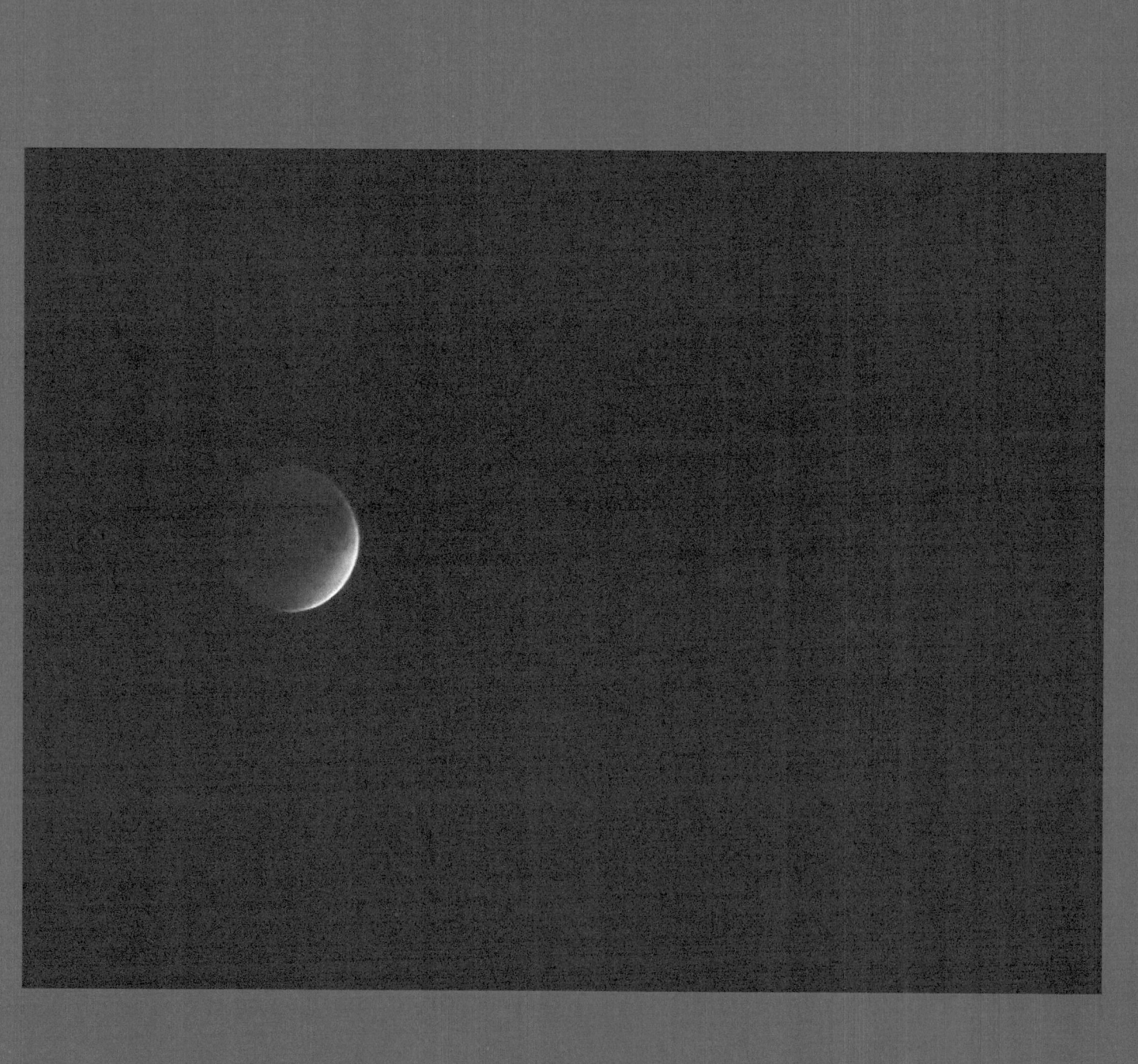

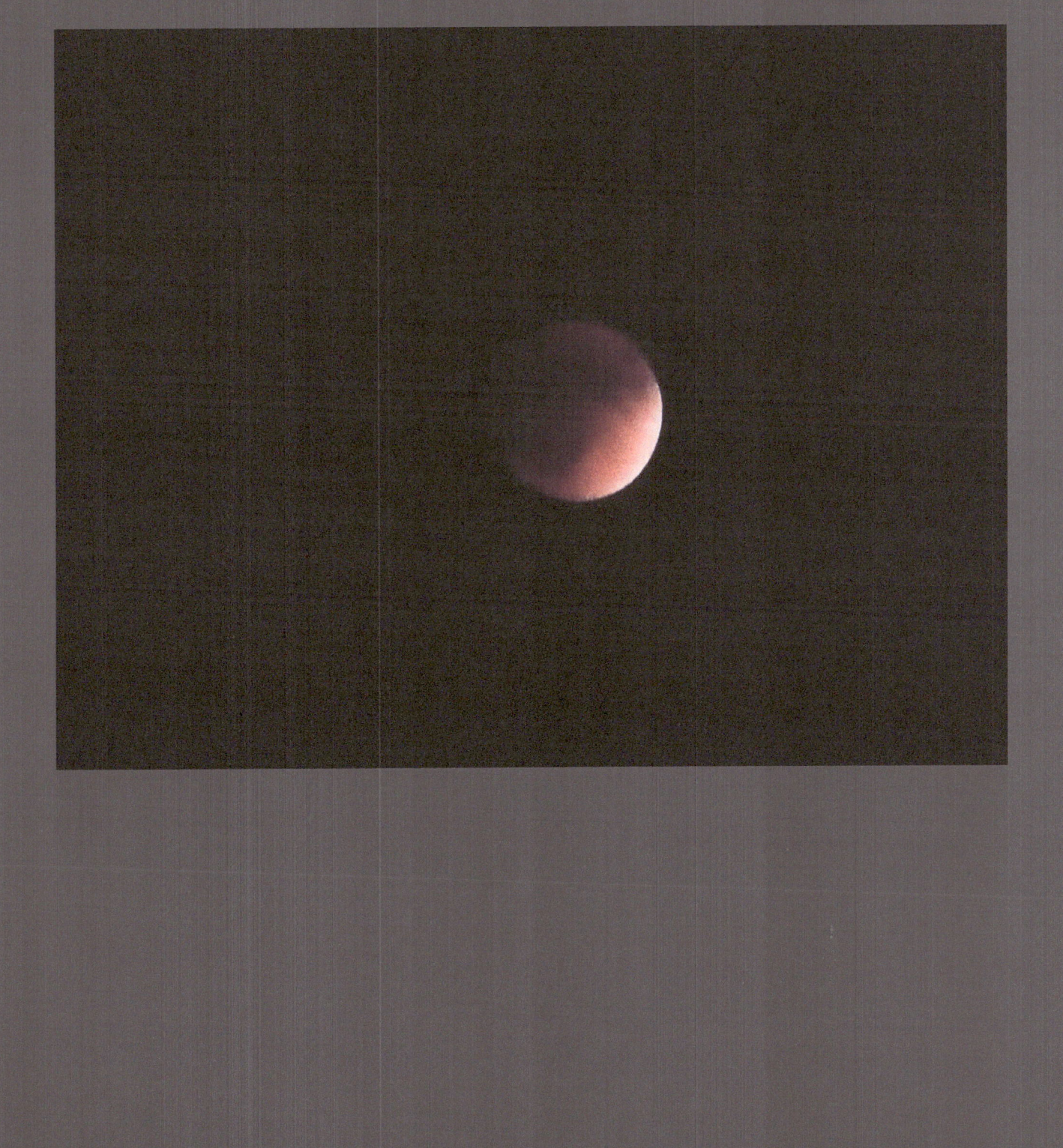

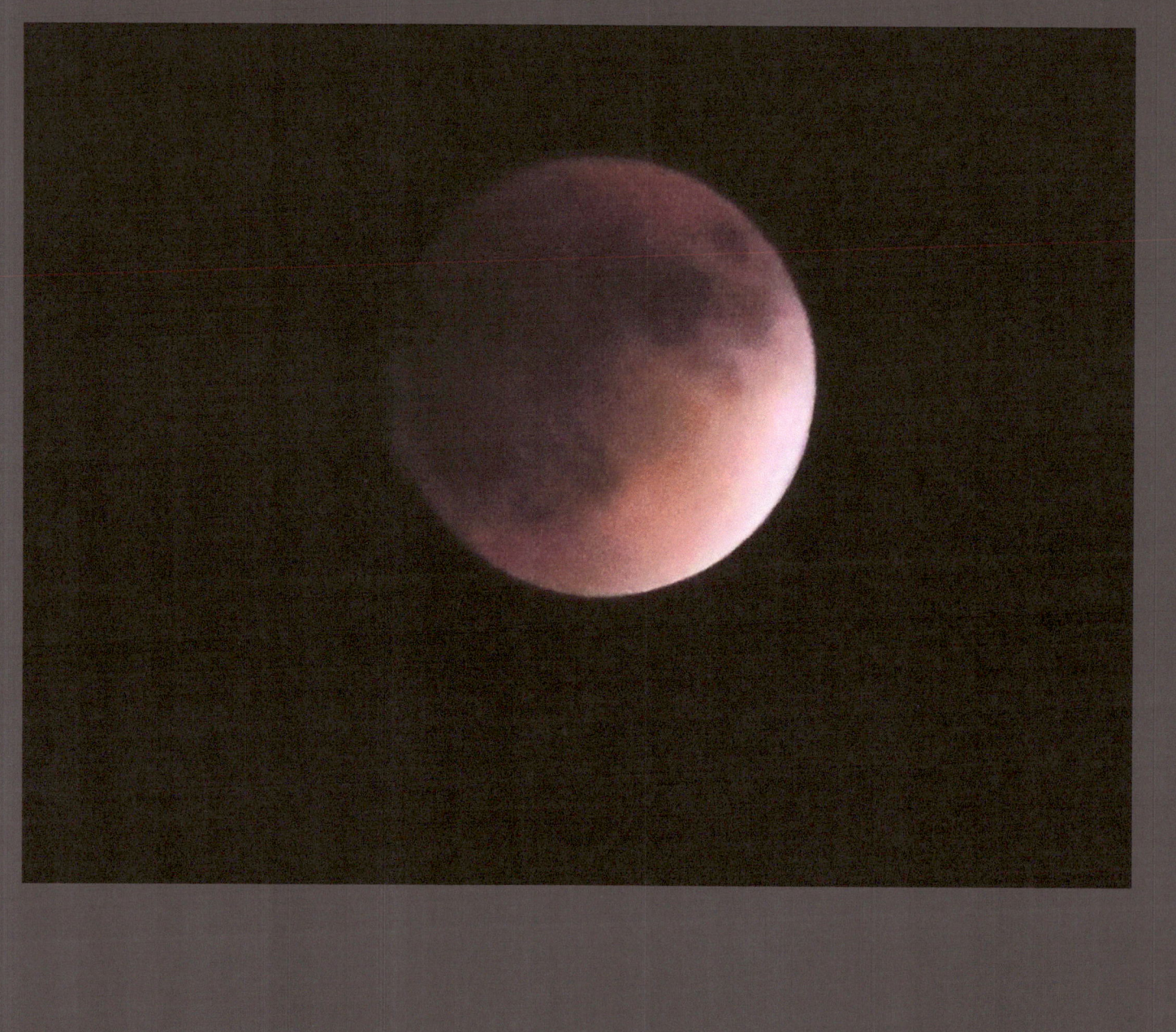

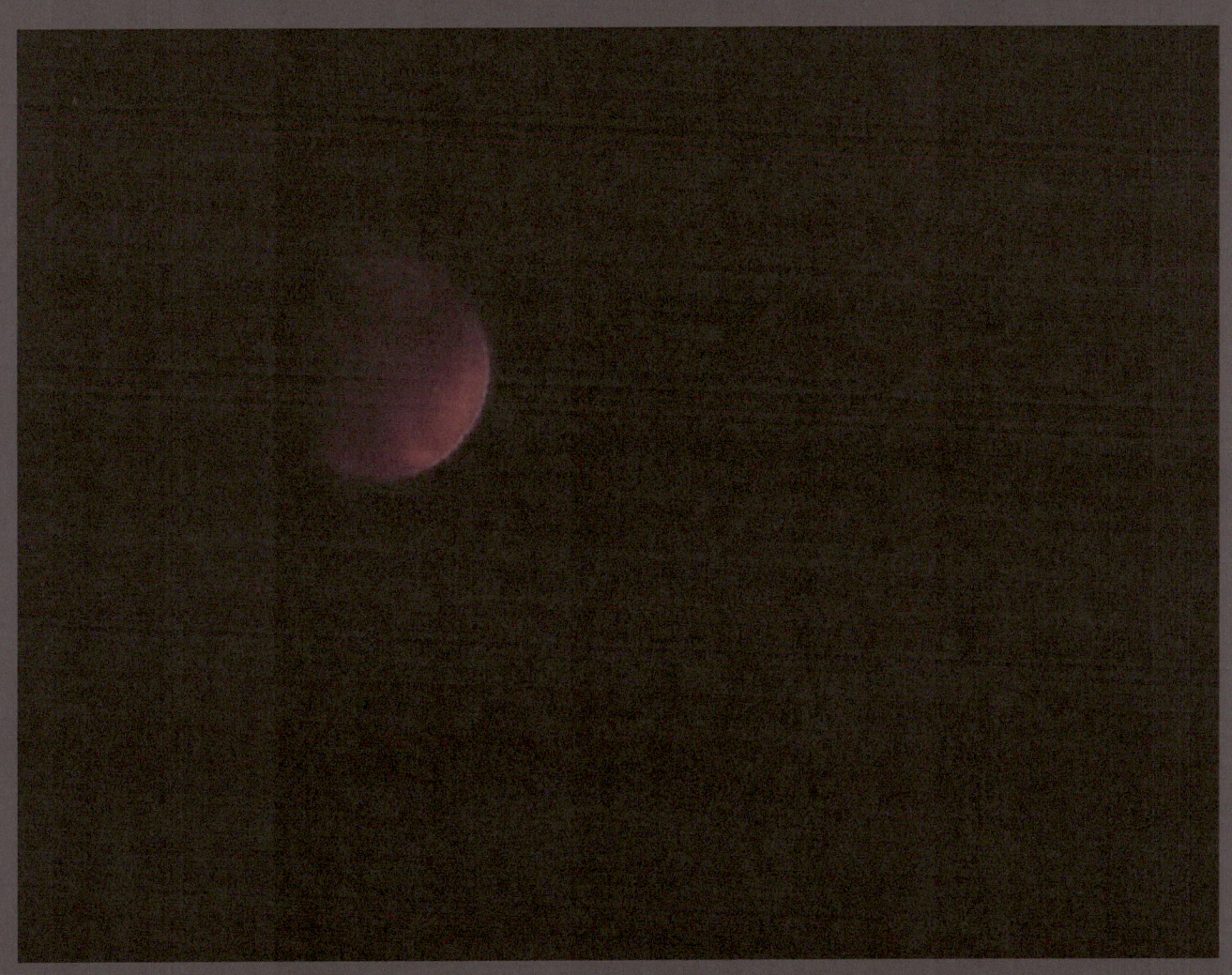

This sight may have alarmed the ancients,
but now it intrigues.
A millennium or two of scientific observation is
responsible for this comfort, and for that I am thankful.

Echo Hill Arts
is pleased to make a new line of
Images from Atwood
Photographic Diversions for Areas of Waiting

available Print on Demand
through **Amazon.com** and **CreateSpace Direct**

Echo Hill Arts Press

www.ingramcontent.com/pod-product-compliance
Lightning Source LLC
Chambersburg PA
CBHW051046180526
45172CB00002B/537